IMAGES
of America

ASHLAND
THE HENRY CLAY ESTATE

ASHLAND
The Henry Clay Estate

IMAGES
of America

ASHLAND
THE HENRY CLAY ESTATE

Eric Brooks

ARCADIA
PUBLISHING

Published by Arcadia Publishing
Charleston, South Carolina

Printed in the United States of America

Library of Congress Catalog Card Number: 2006935062

For all general information contact Arcadia Publishing at:
Telephone 843-853-2070
Fax 843-853-0044
E-mail sales@arcadiapublishing.com
For customer service and orders:
Toll-Free 1-888-313-2665

Visit us on the Internet at www.arcadiapublishing.com

This book is dedicated to my loving wife, Twila Mynhier Brooks.

CONTENTS

ACKNOWLEDGMENTS

For more than half a century, hundreds of people, many of them volunteers, have contributed untold time and talent to preserve Ashland, making it available to the public. To these talented and generous individuals go great appreciation and admiration. Special thanks must also be given to those who preserved the remarkable collection of photographs that remained at Ashland after the last of Henry Clay's descendants moved out. Without these images, this book would not exist.

I must also extend thanks to several colleagues and institutions whose efforts improved this volume immeasurably, including Bill Marshall and Jim Birchfield of the University of Kentucky Department of Special Collections and Digital Projects and B. J. Gooch of Transylvania University Library's Department of Special Collections, all of whom gave generously of their time and resources.

Finally there are several individuals I would like to personally thank for their contributions to this project. Thanks go to Ashland executive director Ann Hagan-Michel and the Board of Directors of the Henry Clay Memorial Foundation for having confidence in the author and allowing the project to go forward. I extend sincere gratitude to Sue Andrew, Ashland collections committee chair, for all her help with gathering material, serving as an editor, and for seeing that the myriad other duties of the curatorial office were carried out during the course of this project. The office could not have functioned without Sue. I wish to offer my gratitude to Wendy Bright-Levy, Ashland weekend manager, for her inspiration and collegiality as we both completed major Ashland projects. Her research was invaluable to this book. Ann, Sue, and Wendy must also be thanked for their invaluable editing, which has made this book significantly better. I must thank my parents, Ken and Vicki Brooks, for all they have done to get me to this point and beyond. This book is for you as much as anyone. Last, but certainly not least, I give thanks to my wife, Twila, through whose love all is possible.

INTRODUCTION

On April 15, 1849, Henry Clay wrote to Rodney Dennis, a Connecticut grocer and admirer: "I am in one respect better off than Moses. He died in sight of, without reaching, the Promised Land. I occupy as good a farm as any that he would have found, if he had reached it; & it has been acquired not by hereditary descent, but by my own labor." Henry Clay deeply loved Ashland, the farm and home he had built upon it. For him, it provided a place of refuge and sanctuary from a difficult and often disappointing world and was one of the few places where Clay regularly found happiness. For Henry Clay's descendants, Ashland was a place of great reverence, inspiration, and attachment. For the students and regent of Kentucky University and the Agricultural and Mechanical College, Ashland was a place of learning, development, and growth. For today's visitors, Ashland is a place of great history, pride, and awe.

In 1804, Henry Clay began to acquire land for a farm for his young family. He had lived in Lexington since 1799, but by 1804, Clay was ready to move from his town home on Mill Street to a more substantial residence on the outskirts of town. By 1809, the center block of his new home was complete and Clay was residing on the farm he named Ashland for the ash trees abundant on the property. By 1811, Clay desired still more room and received plans to add wings to Ashland from Benjamin Latrobe, architect of the Federal Capitol. Within a year or so, the home was a full five-part Federal structure including a center block, two hyphens (connecting pieces), and two end blocks. Clay and his wife, Lucretia Hart, resided at the home until his death in 1852. When Clay died, his will dictated that Lucretia would have a life estate in the property, but when she left or died, the property would be sold. A short time after Clay's death, Lucretia moved to her son John's home (called Ashland on Tates Creek), and Ashland was sold to another of her sons, James.

Upon purchase of Ashland, James Clay found the mansion in a state of serious disrepair. He arrived at the difficult conclusion that there was only one thing to be done: raze the house and rebuild. James had the house torn down, taking care to save all materials that could practically be salvaged. He then rebuilt the home on the existing foundation, following his father's original floor plan. James Clay carefully and thoughtfully rebuilt Ashland as a memorial to his father, Henry Clay. He did incorporate certain Italianate, Greek Revival, and Victorian details in the rebuilding to bring the house into the more current style, but by and large, he intentionally re-created his father's home.

James Clay resided at Ashland until 1862, at which time he fled Lexington because of fear of retribution due to his strong Confederate leanings. He first traveled to Cuba then on to Montreal, where he remained until his death in 1864, never to return to the memorial he built to his father. In 1866, Ashland was bought by John Bryan Bowman to become part of the new Kentucky University.

Bowman moved to Ashland in 1866 and initially used the home as a residence, but after a time, he determined it had more room than he needed. As a result, selected rooms on the first floor were designated for the university's use as a museum. Unfortunately, by the late 1870s, Bowman's

relationship with the university's board of directors had begun to deteriorate and he was fired. He was forced to leave Ashland in 1878. While still owned by Kentucky University, Ashland was rented out until 1882, when it was sold to Henry Clay's granddaughter, Anne Clay McDowell, and her husband, Henry Clay McDowell, who had been named in honor of her famous grandfather. The McDowells returned Ashland to family ownership for the first time in over 17 years.

The McDowells immediately engaged in major renovation and restoration. They kept the house largely the same but made several significant alterations to bring it into a more popular style. Anne and Henry Clay McDowell resided at Ashland until their deaths. At that time, their oldest child, Nannette, occupied the home. Nannette McDowell Bullock, her husband, Thomas, and son, Henry, were the last residents of Ashland, and it is through Nannette's efforts that the Henry Clay Memorial Foundation was created, preserving Henry Clay's legacy, the house, and 17 remaining acres for future generations.

Since 1950, Ashland has been open to the public as a historic house museum. Due to its long and varied history, Ashland may be thought of today as an "onion," the layers of which can be peeled away to reveal the history of the home and its occupants and, remaining at its core, Henry Clay's five-part Federal structure and floor plan. To this core have been added son James Clay's Greek Revival, Italianate, and Victorian flourishes and Eastlake and Aesthetic details added by granddaughter Anne Clay McDowell.

Today Ashland is a National Historic Landmark and site of profound history. It serves as a place of retreat and comfort for many of its neighbors, the people of Lexington, and thousands of people who visit the site each year. Most of all, it is a reminder of the "Promised Land" that Henry Clay and his descendants found here.

One

"I AM IN ONE SENSE BETTER OFF THAN MOSES"
Henry Clay's Promised Land

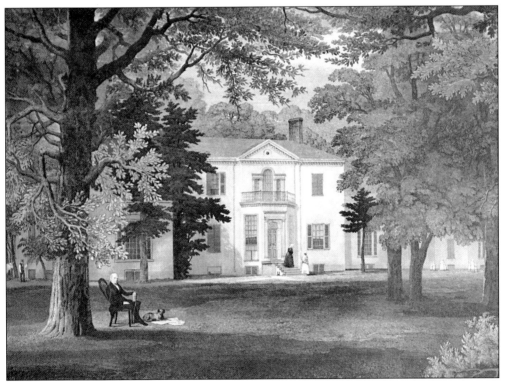

This engraving by John Sartain, entitled *Ashland, the Homestead of Henry Clay near Lexington KY*, printed in 1852, depicts Ashland as it appeared during Henry Clay's lifetime. It was a Federal-style structure that was ultimately whitewashed in a pearl color to improve the integrity of the brick. The engraving shows two women, one possibly intended to represent Henry Clay's wife, Lucretia, standing on the steps. Off to the front left under the tree, Henry Clay relaxes in his chair as if reflecting on the pastoral beauty of Ashland.

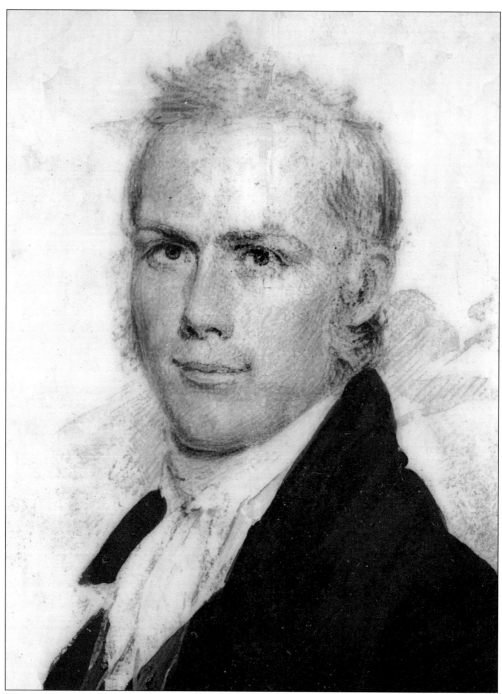

This miniature of Henry Clay painted on ivory, believed to be the earliest known image of him, is thought to have been created by Benjamin Trott in 1805. According to a family friend, Clay's wife, Lucretia, said of her husband that when he was young he had the whitest head of hair she had ever seen. This miniature shows the exuberant and youthful Clay, who had become well established in Lexington with a successful law practice and was ready to start building the farm he had always dreamed of owning. (Courtesy of William LaBach.)

On September 13, 1804, Henry Clay contracted with Cuthbert Banks to purchase a 125-acre "plantation near Lexington on Todds [now Richmond] Road." The purchase marked the beginning of Clay's acquisition of land for his Ashland estate, which ultimately grew to approximately 660 acres. The agreement was actually a contract to buy a patchwork of smaller parcels that had been assembled by Banks. (Courtesy of Transylvania University Library Special Collections.)

Clay was ready to begin Ashland's development, and on January 22, 1805, he contracted with local brick mason John Fisher to construct a "house in the Country." It is uncertain what structure Clay intended to build, but it may have been part of the mansion. The fact that three quarters of it was soft, sand brick could have contributed to the later deterioration of the original Ashland. (Courtesy of Transylvania University Library Special Collections.)

Twenty Dollars Reward!

STRAYED or stolen, several weeks ago, from the farm of the subscriber, near Lexington, a sorrel filley, three years old this spring. Between the knee and fetlock on the side of one of her fore legs is a scar about an inch in length; in her forehead is a long star or blaze, and on close inspection, white hairs may be perceived intermingled with the sorrel. I will give the above reward to any person who will deliver her to me.

4t

Henry Clay.

Ashland, 6th March, 1809.

There is no record of exactly when Henry Clay completed the main block of the original Ashland or when he took residence. He was likely residing at Ashland by 1808. This newspaper advertisement from the March 6, 1809, *Kentucky Gazette* marks the first time Clay mentions Ashland by name. The fact that the advertisement asks for his horse to be returned to Ashland indicates that Clay was already residing there. (Courtesy of the Lexington Public Library.)

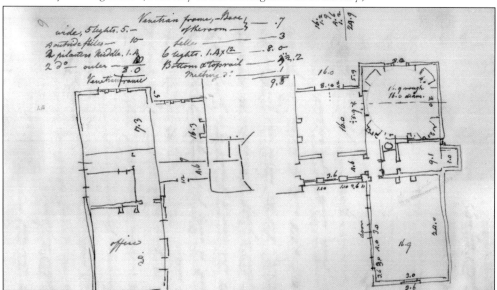

In 1813, Henry Clay asked friend and famed architect Benjamin Latrobe to design wings for Ashland. This sketch shows a library and chambers in the right wing and a kitchen and support spaces in the left. Clay contracted with John Fisher on April 28, 1813, to build the wings. Latrobe later noted that the wings had been built on the opposite sides of the house from the original design. (Courtesy of the Maryland Historical Society.)

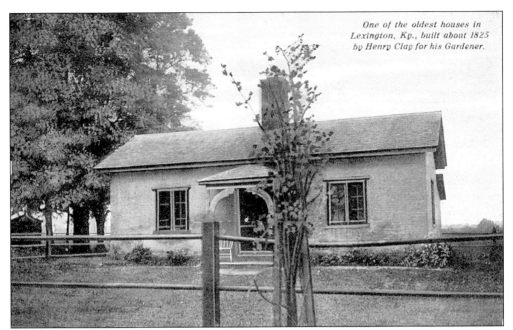

One of the oldest houses in Lexington, Ky., built about 1825 by Henry Clay for his Gardener.

After completing the mansion, Henry Clay turned his focus to the addition of outbuildings to support the home and farm. This small cottage is one of those outbuildings. The postcard pictured here indicates it was the residence of the gardener. It is also likely that it was used as a residence for enslaved and, later, employed African Americans. The building was demolished early in the 20th century.

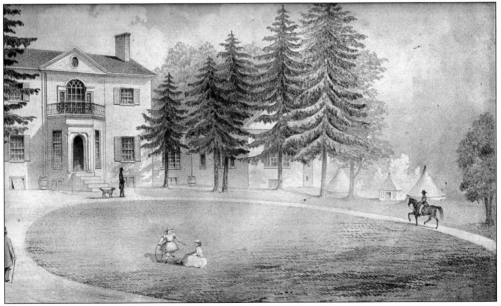

The smokehouse was built in 1817 and can be seen in this lithograph to the right of the large stand of pine trees. It was an important structure on the farm, providing a means of preserving meat butchered there. The Clays cured mainly pork, but beef and other meats were cured. Henry Clay's wife, Lucretia, was well known for her hams and was often complimented on them. The smokehouse remains on the property today.

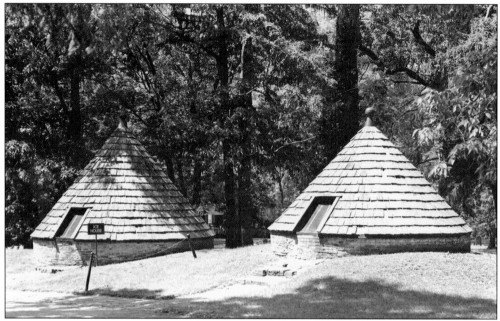

In 1830, Henry Clay improved Ashland by constructing icehouses and a dairy cellar. The first icehouse was built nearest the mansion, then a second was added, and, finally, the dairy cellar. They were filled with blocks of ice harvested from local rivers and lakes. The ice was used to cool foods stored upon it. Runoff ran into the dairy cellar, cooling the milk, cheeses, and other food items stored there.

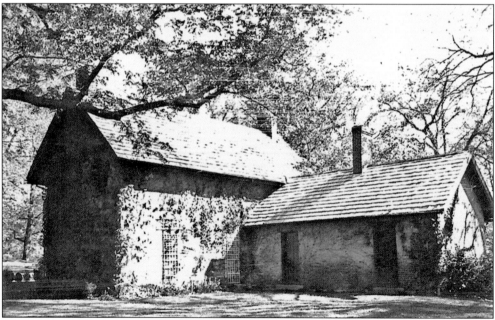

In 1846, Henry Clay's chief gardener required a new residence, so architect Thomas Lewinski was hired. He designed an Italianate structure with two rooms on each of two floors divided by central hallways. The ell at the back housed a kitchen and dining area. The keeper's cottage, as it is referred to today, is used as an office and as programming space by the Henry Clay Memorial Foundation.

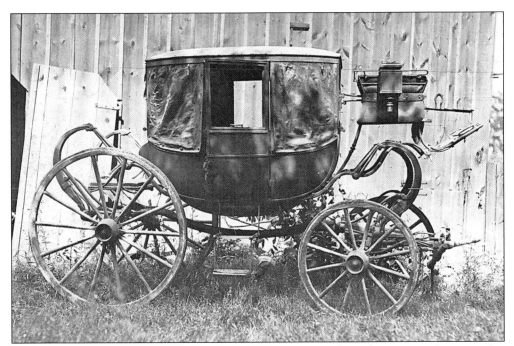

In November 1833, Henry Clay visited Newark, New Jersey, and was shown around town in this carriage. After commenting on how fine it was, the carriage was presented to Clay as a gift from the citizens of Newark. It served Clay for the rest of his life and was used in his funeral procession. Today it is part of Ashland's collection and on display in a recently refurbished carriage house.

At his beloved Ashland, Henry Clay could give careful thought and consideration to the complicated questions of the day as he walked the peaceful grounds of his farm. Clay had many paths to stroll upon as he mulled over these problems in the hope of finding solutions. The path pictured here may or may not have been his favorite, but over time, it has become identified as such.

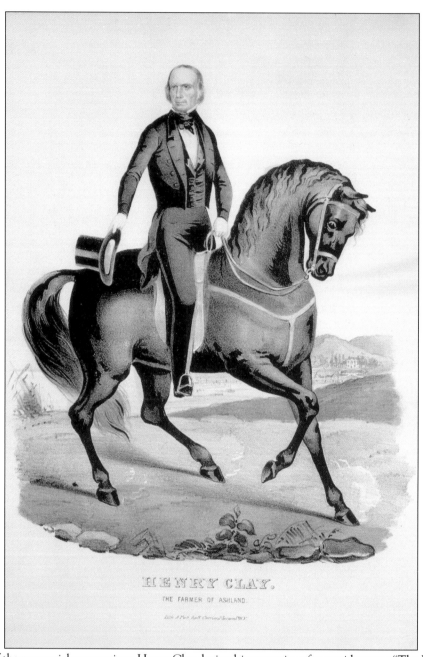

HENRY CLAY.

THE FARMER OF ASHLAND.

One of the many nicknames given Henry Clay during his campaigns for president was "The Farmer of Ashland." The name was designed to appeal to Southern plantation owners who made up a constituency Clay felt he must win over to attain the presidency in 1844. This Nathaniel Currier poster shows Henry Clay as "The Farmer of Ashland" astride his horse. Oddly, although Clay courted the votes of the plantation owners, he generally felt little in common with them. Clay was a serious agriculturalist who spent many hours tending his farm using the most progressive ideas and methods to produce the best possible stock. Clay was known to share his knowledge of farming and breeding through published articles and personal correspondence. He possessed an ongoing desire to improve his own farm and to advise and inform others throughout the nation.

Ashland 1839. Memo.

April. Sent Mary Anne, the spotted cow with a bent horn (Bud Smith) and a young Heifer, daughter of the Broken Knee Cow to Grosvenor, Toms Bull.

Sent the Holstein Cow to Richd Pindells white bull.

3d May. Sent Diana to Grosvenor.

7th the Spotted Cow above mentd with a bent horn took the Pindells bull.

11th Mary Anne was served by Grosvenor.

12th Sent Grosvenor to Mansfield.

14th Sent Pat (Mrs. Clays Cow) and Doctor (Yandells) to R. Pindells white Bull.

4th June My Blossom Heifer was served by Mr. Carrs Bull.

12th The Devon Cow by do

As an astute lawyer and congressman, Henry Clay knew the value of good record keeping. It was a skill he applied fastidiously to his farming activities. Clay recorded breeding activities, kept pedigrees, maintained records of performance at agricultural shows and horse races, and logged sales information. Most of the records were kept in stock journals as are the notes pictured on this page. These particular notes record Clay's cattle breeding schedules for April, May, and June 1839. They indicate that he was actively breeding some of his cattle with those of his neighbor and brother-in-law, Dr. Richard Pindell, as well as with the cattle of his son Thomas and Clay's wife, Lucretia. This page mentions only one breed of cattle, the Holstein, but Clay owned several different breeds and was the first to import Herefords to the United States from England in 1817. (Courtesy of the University of Kentucky Department of Special Collections and Digital Projects.)

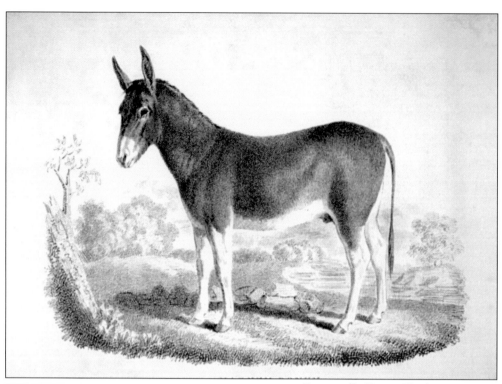

Financially Henry Clay's most important livestock were jacks and jennies. The jacks were bred with mares, producing mules later sold to Southern plantation owners. Magnum Bonum, pictured here, was one of Clay's most prized jacks, and its dam traced back to George Washington's stock. Washington, like Clay, believed in the value of breeding mules as work animals. (Photograph by Mary Rezny.)

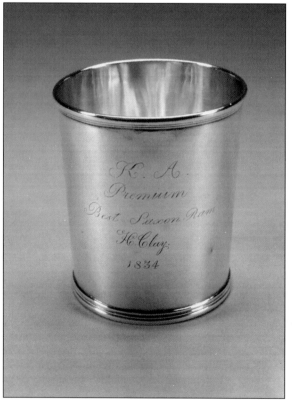

The Kentucky Association for the Improvement of Livestock Breeds regularly held stock competitions. Clay won this cup at an association fair in September 1834 for the best Saxon ram. According to Henry Clay's stock book, this prize ram was then sent to the ewes for breeding. In addition to competing in stock fairs, Clay also served as a judge at many of them. (Photograph by Mary Rezny.)

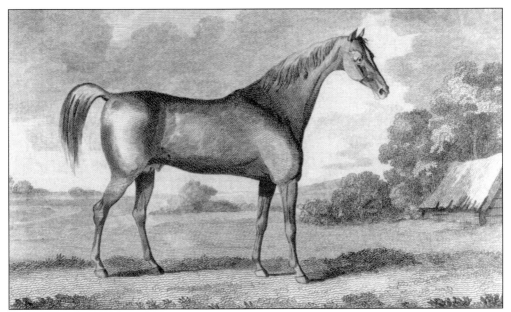

Henry Clay passionately immersed himself in breeding and racing horses. The stallion Buzzard, pictured here, was an imported English horse purchased in partnership with four other men in 1806. It is believed to be the first horse syndication in American history. Buzzard had lost one eye and was lame in one hip, but his pedigree made him a successful stud, improving Kentucky's Thoroughbred bloodlines in the years he stood at Ashland. (Photograph by John Malick.)

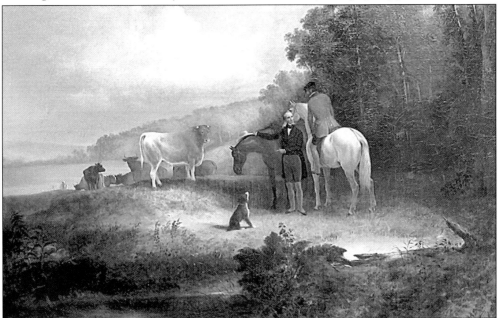

This painting, entitled *An Eventful Day with Henry Clay* by Alvan Fisher, is the only known image of Henry Clay tending his livestock. It depicts an actual incident in which Clay's prize bull, named Orizimbo, spooked and charged Clay's horse. Clay is shown inspecting his horse while son Thomas looks on. An 1836 newspaper account described it differently, indicating Clay was thrown from his horse, which died instantly. (Courtesy of Vose Galleries.)

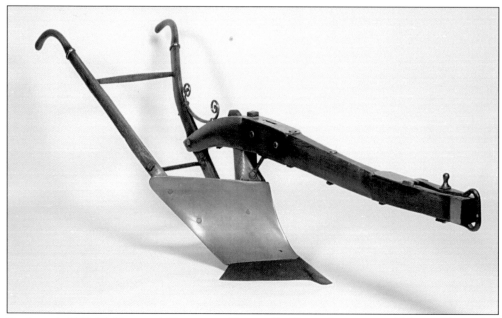

On June 4, 1845, H. Hays and Company of Louisville, Kentucky, presented Henry Clay with a plow. It was delivered to a hardware store in Lexington, where it remained on display for several months. The gift of the plow is indicative of Clay's success as a planter and his interest in the latest agricultural equipment. (Courtesy of the Kentucky Horse Park International Museum of the Horse. Photograph by Mary Rezny.)

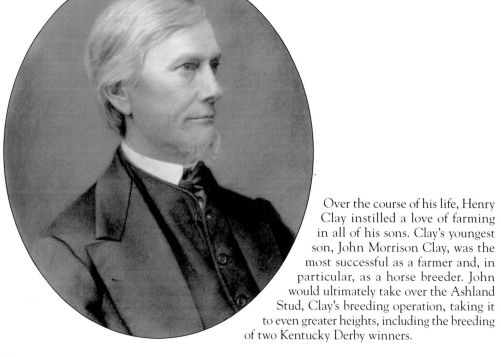

Over the course of his life, Henry Clay instilled a love of farming in all of his sons. Clay's youngest son, John Morrison Clay, was the most successful as a farmer and, in particular, as a horse breeder. John would ultimately take over the Ashland Stud, Clay's breeding operation, taking it to even greater heights, including the breeding of two Kentucky Derby winners.

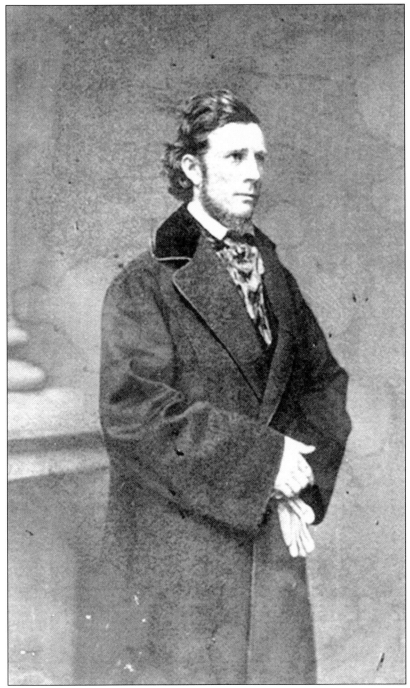

Of Henry Clay's sons, none tried to succeed his father in as many ways as James Brown Clay. Henry Clay arranged for James to serve as a diplomat with a posting to Portugal and gave him a farm in Missouri to try and help him succeed in farming. James took it upon himself to practice law and was elected to a term in the U.S. House of Representatives. While James found some success at all of these things, he ultimately succeeded his father in one way none of his brothers managed to do: he became the master of Ashland. (Courtesy of the Elizabeth Clay Blandford Collection.)

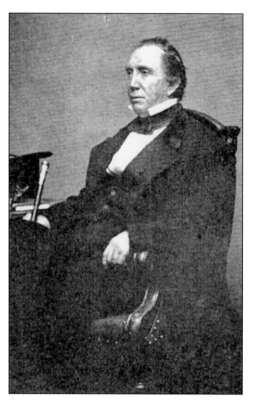

Henry Clay was heavily invested in the cultivating of hemp with son Thomas. Together they owned stock in a local hemp mill producing some rope but mainly manufacturing bagging for the cotton industry. In 1846, Henry Clay built Thomas a house called Mansfield on property adjoining Ashland. Thomas Clay would ultimately follow his father into public service, serving as ambassador to Nicaragua and Honduras under Pres. Abraham Lincoln.

A tragic moment at Ashland occurred on March 30, 1847, when Henry Clay received word of the death of Henry Clay Jr. Henry Jr. had been killed in battle during the Mexican War. The tragic loss of Clay's most promising son may have resulted in his baptism into the Episcopal Church in the parlor at Ashland a short time later. Henry Clay Jr.'s descendants would ultimately own Ashland and preserve it as a museum.

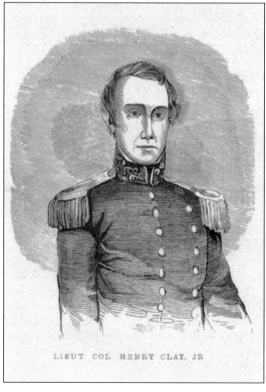

LIEUT COL HENRY CLAY, JR

As a young girl and a member of one of Kentucky's wealthiest families, Mary Todd visited Ashland. Her family lived in downtown Lexington, but Mary was educated at the Mentelle School across from Ashland and would visit with the Clays, showing off her pony-riding skills. Mary Todd married Abraham Lincoln, who considered Clay his "beau ideal of a statesman." Apparently Lincoln never visited Ashland. (Courtesy of the Mary Todd Lincoln House.)

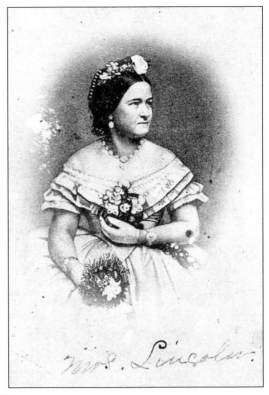

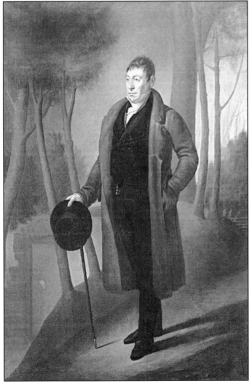

Another important visitor and friend of Henry Clay was the Marquis de Lafayette, who visited Ashland in May 1825 while on a national tour. Lafayette left an absent Henry Clay at least two gifts: a miniature of himself and a Masonic apron now on display at Ashland. It is interesting to note that Ashland is in Fayette County, Kentucky, named in honor of the distinguished Frenchman. (Courtesy of the Kentucky Historical Society.)

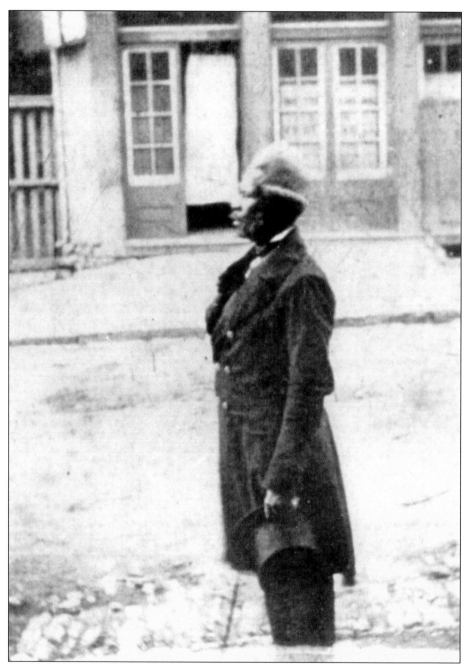

Over the course of his lifetime at Ashland, Henry Clay enslaved over 60 people. These African Americans maintained the home, cooked the food, cared for the needs of the family, and worked the farm. Aaron Dupuy, shown in this photograph, was one of the first slaves owned by Clay and one of the most important. Dupuy eventually attained a position as Clay's personal servant and coach driver. Dupuy ultimately met and married a slave named Charlotte (often referred to as Lotty). He convinced Clay to buy her so that they could live together and raise a family. Lotty also cared for Henry Clay's children and grandchildren. (Courtesy of the University of Kentucky Department of Special Collections and Digital Projects.)

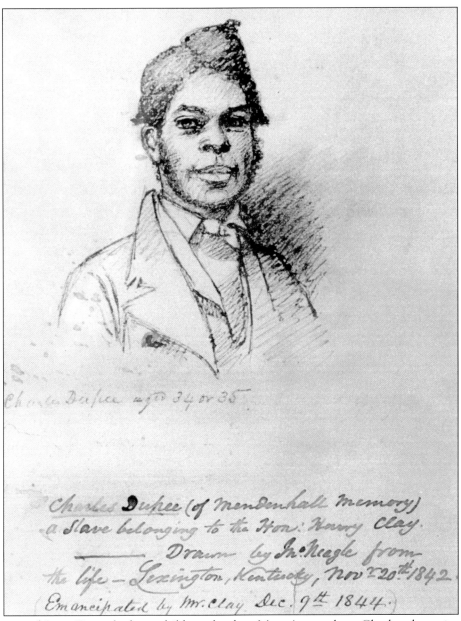

Charles Dupee agd 34 or 35.

"Charles Dupee (of Mendenhall memory)
a Slave belonging to the Hon: Henry Clay.
——— Drawn by Jn Neagle from
the life — Lexington, Kentucky, Novr 20th 1842.
(Emancipated by Mr. Clay Dec. 9th 1844.)

Aaron and Lotty Dupuy had two children: daughter Mary Ann and son Charles, shown in this drawing by John Neagle. Charles, like his father, became a trusted household servant and was granted custody of the keys to the wine cellar. When the artist Neagle came to Ashland in October 1842 specifically to create a painting of Henry Clay to be used as a campaign icon for the Whigs of Philadelphia, Charles Dupuy was assigned to see to his needs. Neagle wrote to a friend that Charles did a fine job of lighting the fire and adjusting windows to create the correct light. Neagle drew this image of Dupuy on November 20, 1842, which refers to Mendenhall, an Indiana Quaker abolitionist who petitioned Henry Clay to free all of his slaves. Clay refused, but as noted on the drawing, ultimately did free Charles Dupuy in 1844. Clay had previously freed Charles's sister and mother. It is uncertain whether Aaron was offered freedom, but he did remain with the family until his death. (Courtesy of a private collector.)

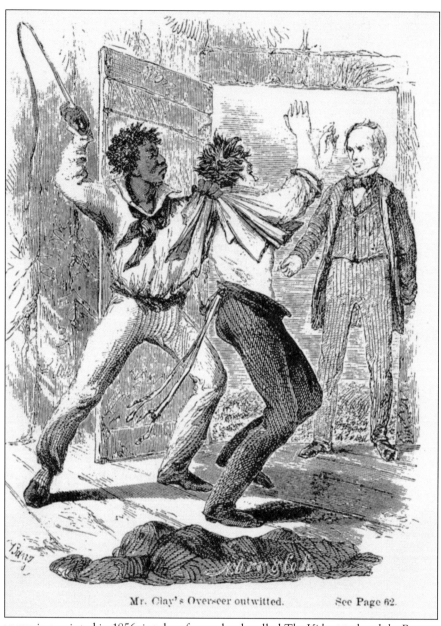

Mr. Clay's Overseer outwitted. See Page 62.

This engraving, printed in 1856, is taken from a book called *The Kidnapped and the Ransomed* by Kate Pickard, a biography of a man named Peter Still who was enslaved for a time at a farm across the road from Ashland. The engraving illustrates an incident Still recalled to the author involving Henry Clay's slave, Aaron Dupuy. Dupuy apparently was to be whipped for drunkenness, but learning of his fate beforehand, he crafted a plan to trick the overseer. Dupuy asked the overseer to remove the same articles of clothing he was instructed to remove for his whipping. The overseer, wanting to ease the whole ordeal, agreed, and as he was removing his shirt, Dupuy grabbed him and began to beat him with his own whip. Henry Clay, hearing the commotion, came running to save his slave from what he thought was an excessive beating. Clay, surprised at finding his slave wielding the whip, ordered Dupuy to stop. The overseer demanded justice but Clay calmly stated there had been enough whipping and the whole matter was over.

26

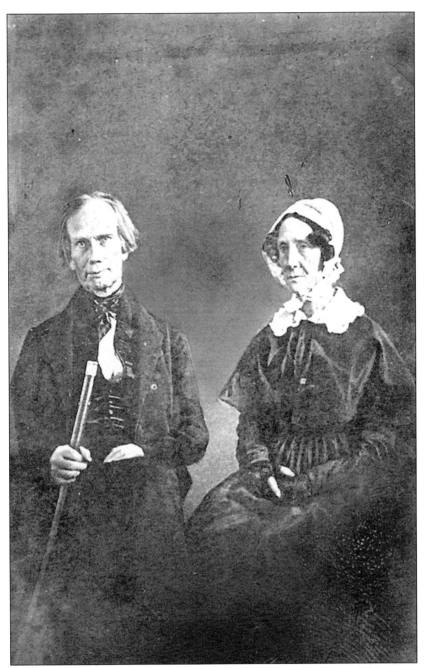

On April 12, 1849, Henry and Lucretia Clay celebrated 50 years of marriage. This daguerreotype marks the occasion. The expression on the faces of both Clays seems to convey the physical and emotional scars of a very public life, especially Clay's three failed presidential campaigns and the sorrow of having to bury 7 of 11 children. Sadly Lucretia would suffer the pain of having to bury yet another child (James in 1864) before her own passing. Henry Clay left Ashland for Washington not long after this photograph was taken to complete his greatest work: the Compromise of 1850. Clay had little time to enjoy his beloved Ashland in the last few years of his life. (Courtesy of the University of Kentucky Library Department of Special Collections and Digital Projects.)

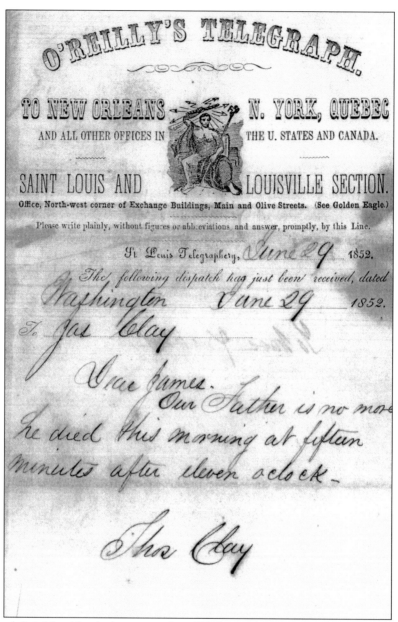

O'REILLY'S TELEGRAPH.

TO NEW ORLEANS — N. YORK, QUEBEC
AND ALL OTHER OFFICES IN THE U. STATES AND CANADA.

SAINT LOUIS AND LOUISVILLE SECTION.

Office, North-west corner of Exchange Buildings, Main and Olive Streets. (See Golden Eagle.)

Please write plainly, without figures or abbreviations and answer, promptly, by this Line.

St. Louis Telegraphery, *June 29* 1852.

The following dispatch has just been received, dated

Washington *June 29* 1852.

To Jas Clay

Dear James.
Our Father is no more he died this morning at fifteen minutes after eleven oclock—

Thos Clay

Henry Clay left Ashland for the last time in late 1851, having been persuaded to take one final foray into the Senate. His plan was to retire the following August. Unfortunately the tuberculosis from which Clay had suffered for many years would not permit him the luxury of retirement. While in Washington, his condition deteriorated rapidly, and on April 28, 1852, he summoned son Thomas to his side. Thomas remained with his father until, on June 29, 1852, at 11:15 a.m., Henry Clay breathed his last. Thomas sent this telegram home, informing the family of their tragic loss. In recognition of his long and distinguished service to the Union, Congress accorded Henry Clay the honor of being the first statesman to lie in state in the Capitol Rotunda. Afterward Clay's body made its way to Ashland on a funeral train that made a circuit through the nation. "Harry of the West" arrived home on Friday evening, July 9, 1852. Clay's body was placed in the dining room, where his wife, Lucretia, kept vigil all night. (Courtesy of the Library of Congress.)

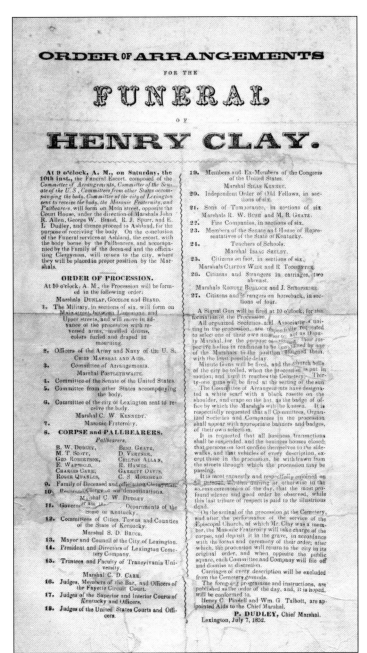

ORDER OF ARRANGEMENTS

FOR THE

FUNERAL

OF

HENRY CLAY.

At 9 o'clock, A. M., on Saturday, the 10th inst., the Funeral Escort, composed of the Committee of Arrangements, Committee of the Senate of the U. S., Committees from other States accompanying the body, Committee of the city of Lexington sent to receive the body, the Masonic Fraternity, and Pallbearers, will form on Main street, opposite the Court House, under the direction of Marshals John R. Allen, George W. Brand, R. J. Spurr, and E. L. Dudley, and thence proceed to Ashland, for the purpose of receiving the body. On the conclusion of the Funeral services at Ashland, the escort, with the body borne by the Pallbearers, and accompanied by the Family of the deceased and the officiating Clergyman, will return to the city, where they will be placed in proper position by the Marshals.

ORDER OF PROCESSION.

At 10 o'clock, A. M., the Procession will be formed in the following order:

Marshals DUNLAP, GOODLOE and BEARD.

1. The Military, in sections of six, will form on Main street, between Limestone and Upper streets, and will move in advance of the procession with reversed arms, muffled drums, colors furled and draped in mourning.

2. Officers of the Army and Navy of the U. S. CHIEF MARSHAL AND AIDS.

3. Committee of Arrangements. Marshal POSTLETHWAITE.

4. Committee of the Senate of the United States.

5. Committee from other States accompanying the body.

6. Committee of the city of Lexington sent to receive the body. Marshal C. W. KENNEDY.

7. Masonic Fraternity.

8. CORPSE and PALLBEARERS. Pallbearers,

B. W. DUDLEY,	BENJ. GRATZ,
M. T. SCOTT,	D. VERTNER,
GEO ROBERTSON,	CHILTON ALLAN,
E. WARFIELD,	R. HAWES,
CHARLES CARR,	GARRETT DAVIS,
ROGER QUARLES,	C. S. MOREHEAD.

9. Family of Deceased and officiating Clergyman.

10. Reverend Clergy of all denominations. Marshal C. W. DUDLEY.

11. Governor and the Departments of the State of Kentucky.

12. Committees of Cities, Towns and Counties of the State of Kentucky. Marshal S. D. BRUCE.

13. Mayor and Council of the City of Lexington.

14. President and Directors of Lexington Cemetery Company.

15. Trustees and Faculty of Transylvania University. Marshal C. D. CARR.

16. Judges, Members of the Bar, and Officers of the Fayette Circuit Court.

17. Judges of the Superior and Inferior Courts of Kentucky and Officers.

18. Judges of the United States Courts and Officers.

19. Members and Ex-Members of the Congress of the United States. Marshal SILAS KENNEY.

20. Independent Order of Odd Fellows, in sections of six.

21. Sons of Temperance, in sections of six. Marshals R. W. BUSH and M. B. GRATZ.

22. Fire Companies, in sections of six.

23. Members of the Senate and House of Representatives of the State of Kentucky.

24. Teachers of Schools. Marshal ISAAC SHELBY.

25. Citizens on foot, in sections of six. Marshals CLIFTON WEIR and R. TODHUNTER.

26. Citizens and Strangers in carriages, two abreast. Marshals ROBERT BULLOCK and J. SCROGSHIRE.

27. Citizens and Strangers on horseback, in sections of four.

A Signal Gun will be fired at 10 o'clock, for the formation of the Procession.

All organized Societies and Associations uniting in the procession, are respectfully requested to select one of their own number to act as Deputy Marshal, for the purpose of keeping their respective bodies in readiness to be conducted by one of the Marshals to the position assigned them, with the least possible delay.

Minute Guns will be fired, and the church bells of the city be tolled, when the procession is put in motion; and until it reaches the Cemetery. Thirty-one guns will be fired at the setting of the sun.

The Committee of Arrangements have designated a white scarf with a black rosette on the shoulder, and crape on the hat, as the badge of office by which the Marshals will be known. It is respectfully requested that all Committees, Organized Societies and Companies in the procession shall appear with appropriate banners and badges, of their own selection.

It is requested that all business transactions shall be suspended, and the business houses closed; that persons on foot confine themselves to the sidewalks, and that vehicles of every description, except those in the procession, be withdrawn from the streets through which the procession may be passing.

It is most earnestly and respectfully enjoined on all persons, whether during or otherwise in the solemn ceremonies of the day, that the most profound silence and good order be observed, while this last tribute of respect is paid to the illustrious dead.

On the arrival of the procession at the Cemetery, and after the performance of the service of the Episcopal Church, of which Mr. Clay was a member, the Masonic Fraternity will take charge of the corpse, and deposit it in the grave, in accordance with the forms and ceremony of their order; after which, the procession will return to the city in its original order, and when opposite the public square, each Committee and Company will file off and dismiss at discretion.

Carriages of every description will be excluded from the Cemetery grounds.

The foregoing programme and instructions, are published as the order of the day, and, it is hoped, will be conformed to.

Henry C. Pindell and Wm. G. Talbott, are appointed Aids to the Chief Marshal.

P. DUDLEY, Chief Marshal.

Lexington, July 7, 1852.

Henry Clay, his body having finally returned home on July 9, 1852, was buried the following day in the Lexington Cemetery. Funeral services were performed at Ashland, and the body, in a cast-iron coffin, was placed in a hearse. A procession commenced from Ashland into town, where a parade accompanied it to the cemetery. Lucretia Clay was too old and frail to go, but she was well represented by her sons. Henry Clay was buried in the plot he had been given as a gift by the cemetery founder. He was buried next to his mother, whose body he had recently moved from her farm in Woodford County. Clay would remain in this plot until 1864, when Lucretia died. At this time, they were both interred in the massive Clay monument, begun 12 years earlier in his honor.

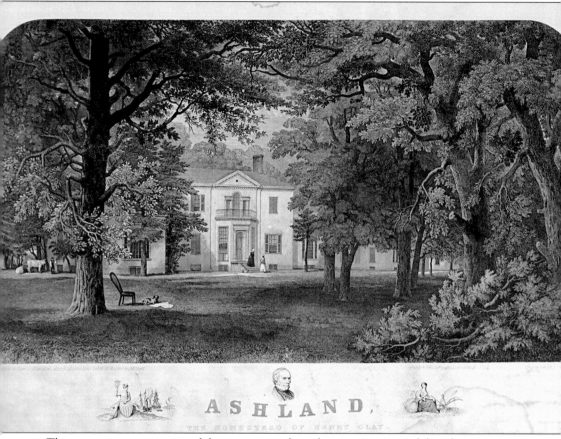

ASHLAND,
THE HOMESTEAD OF HENRY CLAY.

This engraving is a version of the one pictured on the opening page of this chapter. However, there is one major difference: the chair under the tree on the left is now empty, Henry Clay having passed away and left his beloved "Promised Land" for good. After Henry Clay died, his will determined the fate of his estate. It specified that his wife Lucretia would receive a life estate and that upon her death or departure from the property, it was to be sold at auction. Lucretia lived for a short time at Ashland but ultimately decided to live with her son John in his home on adjoining land left to him by his father. The property was sold at public auction on September 20, 1853, and purchased by Clay's son James for $140 an acre. Unfortunately James would soon find that the mansion at Ashland was structurally unsound, and he would have to make a difficult decision about its future.

Two

RE-CREATING ASHLAND AND A HOUSE DIVIDED
James Brown Clay and the Civil War

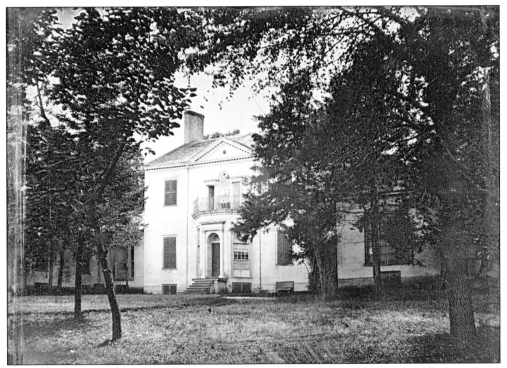

When son James Brown Clay took ownership of Ashland in 1853, the home had not been renovated or substantially refurbished in many years and, as a result, had fallen into significant disrepair. The once-stately home had suffered structural damage during the New Madrid earthquakes of 1811. This is the only known photograph of Henry Clay's original Ashland, taken not long after his death when James purchased it, showing the overall deterioration. Whitewash had been applied years earlier in an attempt to stabilize the deteriorating brick. (Courtesy of the George Eastman House.)

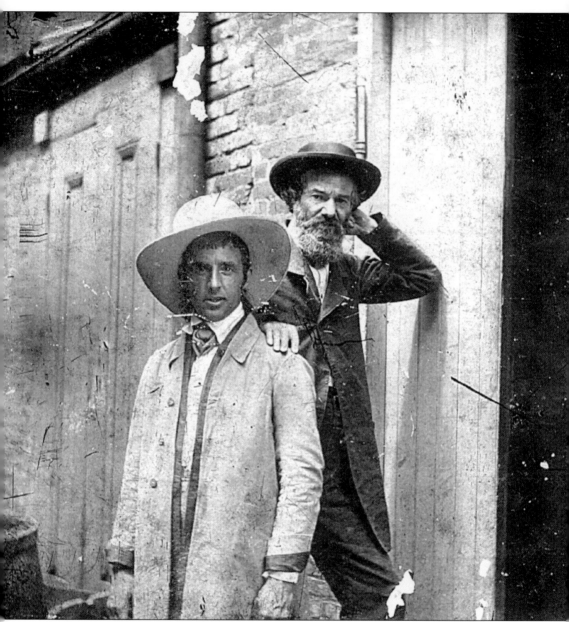

Having determined Ashland to be structurally unstable, James Brown Clay contacted his father's favorite local architect, Thomas Lewinski (right), for help. Lewinski, who had previously designed Henry Clay's gardener's cottage and homes for sons Thomas and James, determined there was no choice but to rebuild the house. Lewinski designed a new Ashland mansion using the original floor plan and existing foundation. In 1854, demolition of the old house began. Lewinski is shown here with a man named Sam Brown, Henry and Lucretia Clay's nephew (left). (Courtesy of Transylvania University Library Special Collections.)

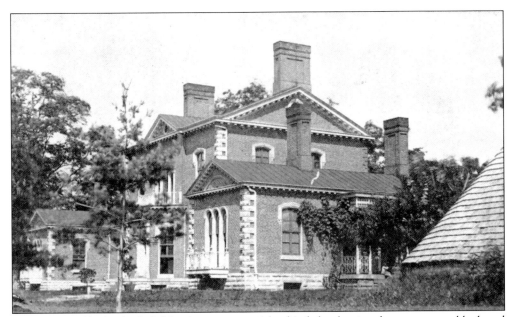

James Brown Clay's rebuilt Ashland was a memorial to his father having the same center block and wing structure. Significant differences include the Italianate details: quoins (or cornerstones), small balconies and iron railings, iron window trims, and long, narrow windows. James Clay moved his family into their new home by Christmas 1856. (Courtesy of the University of Kentucky Library Department of Special Collections and Digital Projects.)

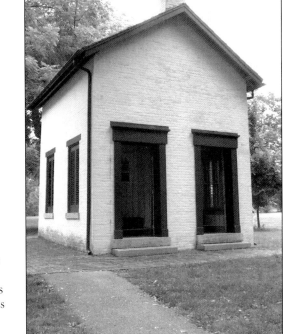

Archaeological investigations have shown that James dumped architectural refuse into the original privy and then built the new one pictured here. This building has two two-hole toilets on one side and a washroom for laundry on the other. The proximity to the house of this privy proved problematic later as the flies it attracted became a nuisance to the kitchen in the mansion.

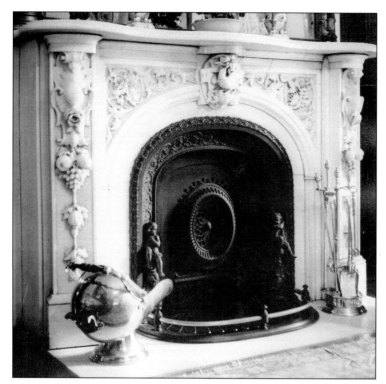

While refurbishing Ashland's interior, James spent lavishly in New York emporiums, buying fine furniture and appointments from around the world. He ordered Italian marble mantels, each of a unique color and design. The more elaborate mantels were designated for the public rooms on the first floor. This particular mantel was ordered for the front, or formal, end of the double parlor. James also selected the iron summer covers for the fireplaces, one of which is shown in this photograph.

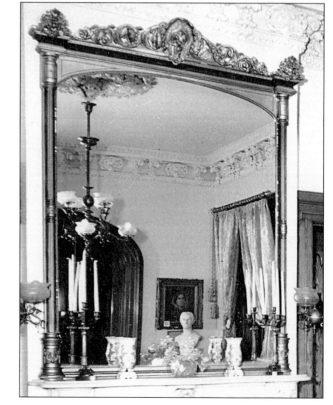

This mirror is one of a pair that James bought for the double parlor at Ashland. They were purchased in New York at a cost of $225 each, an exorbitant sum at the time. This one remains at Ashland, but the other has long since disappeared. The pocket doors dividing the parlors can be seen reflected in the mirror.

To furnish his bedchamber, James ordered a custom chamber suite believed to have been made from ash trees on the property at Ashland. This wardrobe and chair are part of the set. The wardrobe has a paper label inside identifying it as having been made for James Brown Clay. The maker of this suite is unknown.

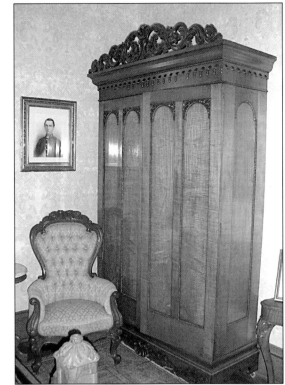

These pieces are also part of James Clay's chamber suite. There are compartments on either side of the mirror for storage of small personal items. The carving on the mirror is a spectacular example of Victorian decoration.

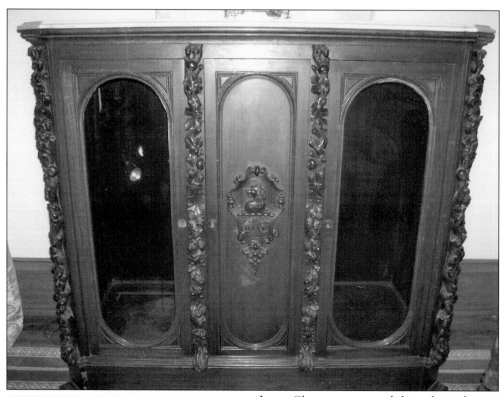

James Clay commissioned this cabinet for use in his parlor to display a large silver urn given to Henry Clay by the Gold and Silver Artisans of the City of New York. James made sketches of the piece, and Thomas Lewinski may have provided final drawings. The piece was fabricated by furniture maker John Henry Belter of New York. James's descendants donated both the cabinet and the urn it was built to hold to Ashland.

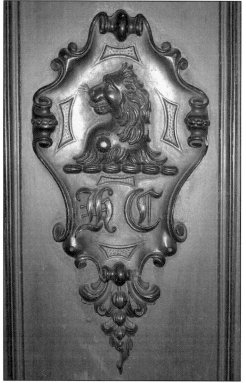

This crest is a decorative element from the Belter cabinet James Clay had built to display his father's silver urn. It is a design of James's own creation using heraldic elements to represent the Clay family, although Henry Clay had no such family device. James used these arms as a personal seal and also displayed them over the front door to Ashland, where they remain today.

Like many wealthy men of his era, James Brown Clay probably had a study in his home. This chair, one of a pair, was likely used in that study. The chairs are attributed to George Henkels of Philadelphia. The back splat is made of a pair of intertwined heraldic dolphins. The arms terminate in lion heads.

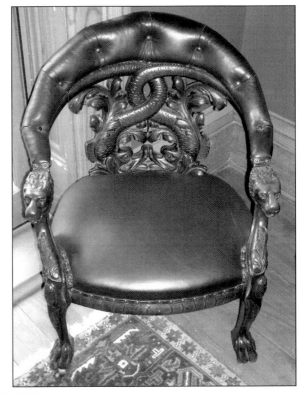

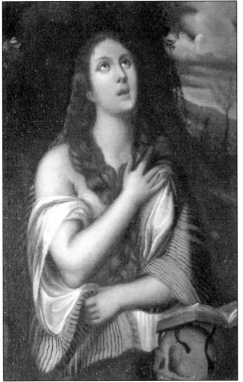

Some of James Clay's furnishings came to Ashland from his previous residences. This painting is one such example. James commissioned this work while serving as chargé d'affaires in Portugal in 1849. It is a copy of Titian's *St. Mary Magdalen in Penitence*, painted in 1531.

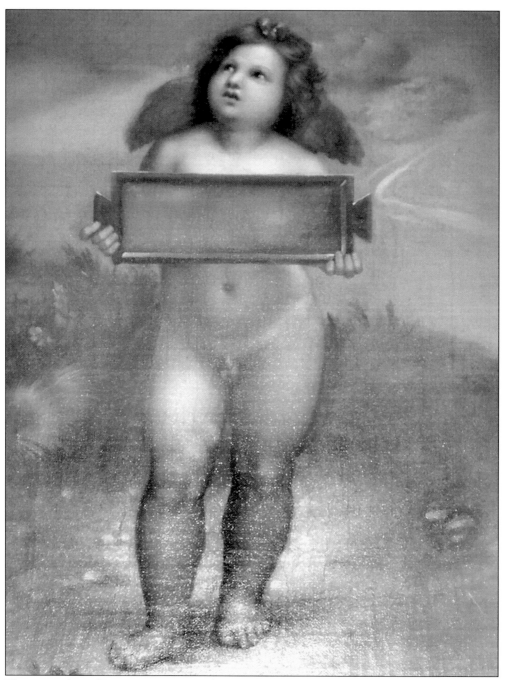

This is another of James's commissioned European copies. It is of a *putto*, or angel, taken from Raphael's early-16th-century painting *Madonna of Foligno*. James commissioned a total of three works copied from famous Renaissance originals. His son Thomas said that his father "did not buy them, until after he had compared them with the Originals, and found them to be most excellent copies."

There are very few images of James Brown Clay and his family at Ashland. Photography was still a relatively new art form, and taking informal pictures was not widely done. This image of Ashland was taken between 1857 and 1862. The man on the far right past the horse may be James, and the woman in the white dress is thought to be his wife, Susan Jacob Clay. The other person is unidentified. (Courtesy of the University of Kentucky Library Department of Special Collections and Digital Projects.)

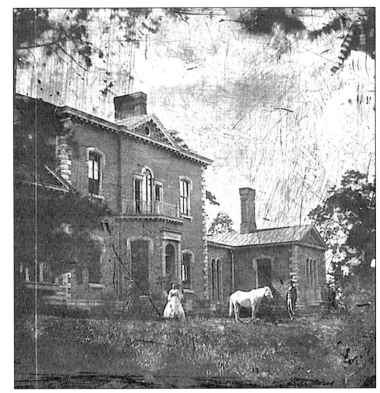

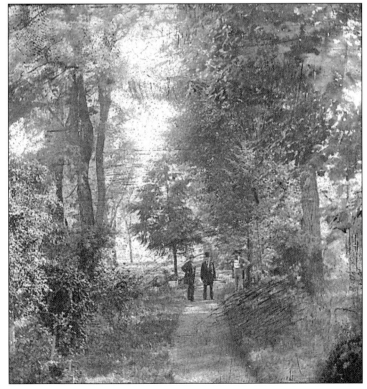

This is another image believed to be of James Clay at Ashland. James (far right) is pictured with two unidentified gentlemen on one of the many walking paths crisscrossing Ashland.

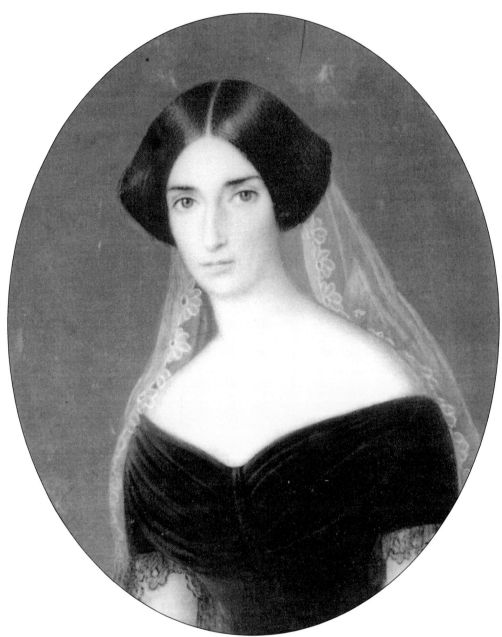

One of James Clay's biggest supporters in his decision to buy his father's Ashland estate was his wife, Susan. This miniature portrays her at age 26. Susan Jacob Clay was a member of one of Kentucky's wealthiest families, the Jacobs of Louisville. Upon marrying James, she became an ardent admirer of her father-in-law, Henry Clay, and sometimes served as his secretary. Susan bore James 10 children, 5 of whom were born at the Ashland estate. Susan was the backbone of her family, holding it together through tragic loss and civil war. She continued to maintain Ashland after her husband fled to Canada in 1862.

Lucy Jacob Clay was James and Susan's oldest daughter. Lucy was 12 years old when her family moved into the new Ashland. This miniature shows Lucy as a child. Lucy died of diphtheria at Ashland on March 7, 1863, at the age of 18. She was the second of three children James and Susan Clay would bury in 18 months. Their youngest child, Nathaniel, had died just 10 months earlier.

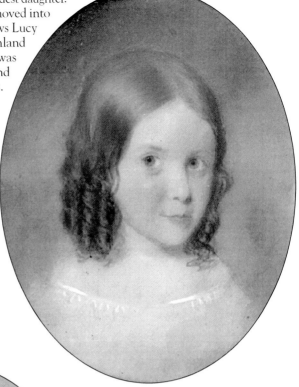

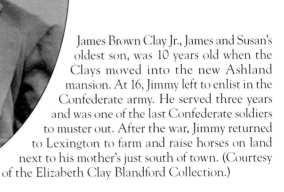

James Brown Clay Jr., James and Susan's oldest son, was 10 years old when the Clays moved into the new Ashland mansion. At 16, Jimmy left to enlist in the Confederate army. He served three years and was one of the last Confederate soldiers to muster out. After the war, Jimmy returned to Lexington to farm and raise horses on land next to his mother's just south of town. (Courtesy of the Elizabeth Clay Blandford Collection.)

James and Susan's second son, John Cathcart Johnston Clay, spent some of his childhood at Ashland but left to accompany his mother to Canada in 1863 to be reunited with his father. John, named for a friend of Henry Clay's, opened a law practice with his brother Harry in California. John contracted cholera and died at the age of 24 while visiting family in Lexington. (Courtesy of the Elizabeth Clay Blandford Collection.)

Henry "Harry" Independence Clay was born in Portugal and christened onboard the USS *Independence*, thus his middle name. Harry entered legal practice with his brother John. When John died of cholera, Harry was devastated. He continued to practice law but ultimately abandoned it to join an Arctic expedition in 1880. Harry's life tragically ended in 1884, at the age of 34, when he was shot in a bar in Louisville, Kentucky.

Most of what is known about James and Susan Clay's children is known through the efforts of their daughter Lucretia, nicknamed "La Petite" or "Teetee." She wrote brief biographies of her siblings and parents and transcribed documents written by her mother. Her writings contain fascinating details of the lives of the James Clay family and their time at Ashland. (Courtesy of the Elizabeth Clay Blandford Collection.)

Thomas Jacob (left) and George (right) were sons of James and Susan Clay. Thomas was the last child born in the original Ashland mansion. He grew up to join the military and helped escort Geronimo to his confinement at St. Augustine. Thomas and George became important horse breeders on their mother's farm, called Balgowan (now part of Calumet Farm). People living in Lexington today still remember "Captain Tom and Mr. George." (Courtesy of the Elizabeth Clay Blandford Collection.)

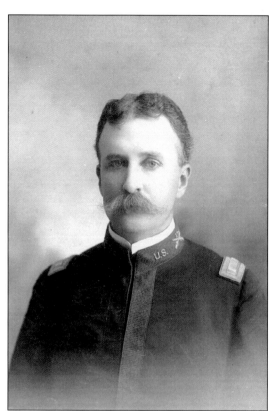

Charles Donald Clay was the first child of James and Susan born in the rebuilt Ashland and the only one to have children. Many items now in Ashland's collection were passed to Charles's descendants, who ultimately donated them to the estate. Charles had a distinguished military career, serving in both the Spanish American War and World War I. (Courtesy of the Elizabeth Clay Blandford Collection.)

This drawing is one of the few reminders of James and Susan Clay's daughter Susan, or "Sukie," as she was often called. The drawing is likely of Christmas at Ashland in 1862, which was Sukie's last. She died of diphtheria the next year at the age of eight. It was also the last Christmas Susan Clay and her children would spend at Ashland. (Courtesy of the Library of Congress.)

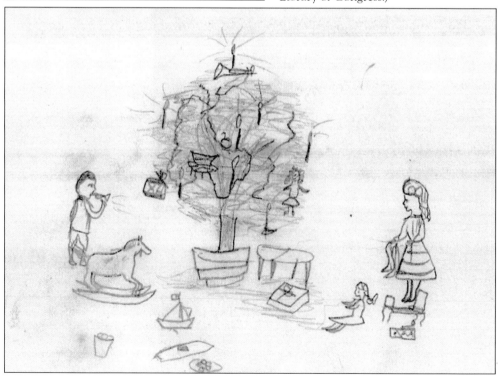

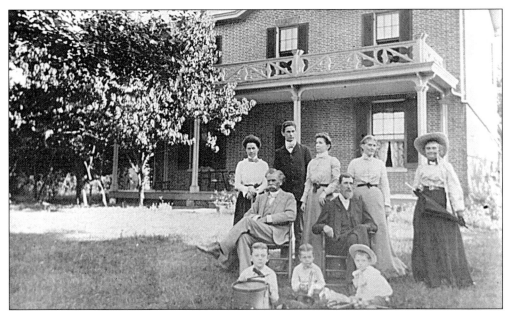

James's brother John Clay developed Ashland Stud on his farm, Ashland on Tates Creek, located on the Tates Creek Pike side of Henry Clay's property. John and his wife, Josephine Russell, made Ashland Stud one of the most successful horse breeding operations in the country. This photograph shows Josephine (far right) in front of Ashland on Tates Creek with her daughters, their husbands, and children. (Courtesy of Henry Clay Simpson Jr.)

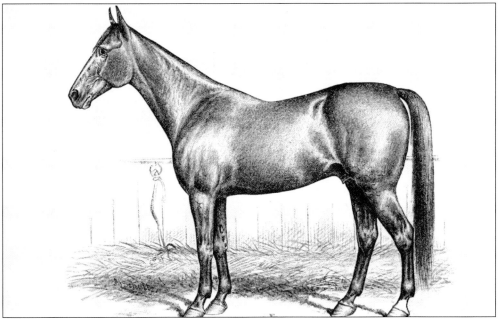

Like his father, James Brown Clay became very interested in horses and ultimately purchased a Standardbred named Mambrino Chief and brought him back to Ashland, where he stood at stud for three seasons. Mambrino Chief produced some of the greatest Standardbred pedigree lines. This image, from *Chester's Trotting and Pacing Record*, is the only known of him. James lent prestige to the then less important Standardbred segment of the horse industry.

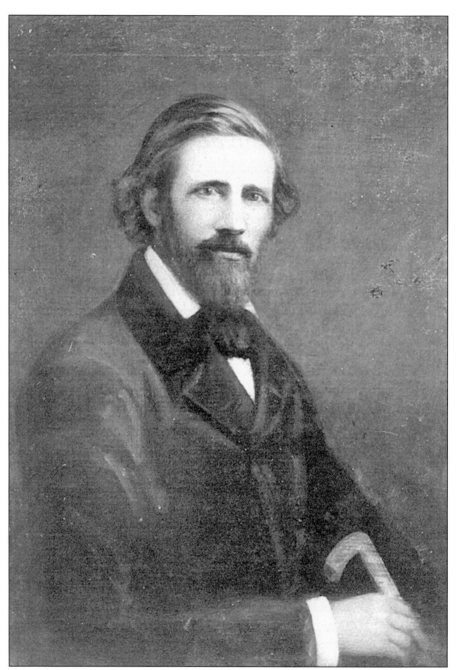

By 1861, the specter of civil war loomed large at Ashland. James Clay, shown here in 1860, became very concerned about the potential dissolution of the Union. When the peace conference he attended in January 1861 failed to preserve the Union, James was forced into a difficult and fateful choice. With the strong support of his wife, Susan, he chose to ally with the Confederacy. In late 1861, James, as a Confederate sympathizer, was arrested while fleeing a pro-Union Kentucky. He was later released but decided to flee once again in 1862 when the Battle of Perryville ended the Confederacy's attempt to take the state. He then traveled to Cuba, ultimately ending up in Canada in 1863. He died in exile in Montreal the following year.

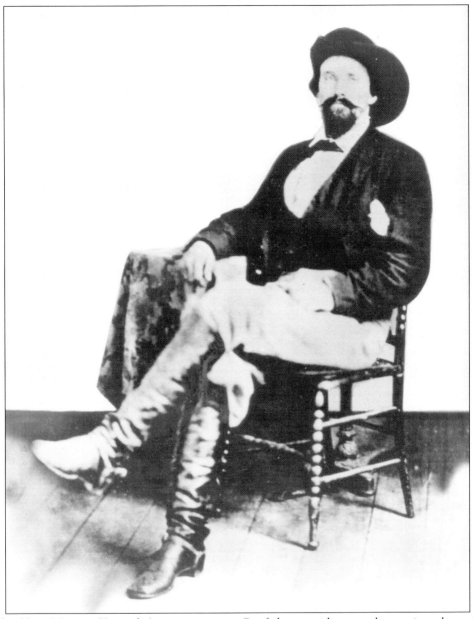

John Hunt Morgan, Kentucky's most notorious Confederate raider, was also motivated to take action following the 1862 Battle of Perryville. Morgan, as an ally of Confederate general Braxton Bragg, decided he could help protect Bragg's troops as they retreated from Kentucky by distracting the Union troops located farther north. Upon learning from a scout that two Union battalions of the 3rd and 4th Ohio Cavalry were encamped in the woods behind Ashland, Morgan decided to launch a surprise attack. On October 18, 1862, at dawn, 1,800 men under Morgan's command swooped down upon the 294 men of the Union battalions. In order to capture as many troops as possible and prevent escape, Morgan divided his forces and attacked the Union troops from both the front and rear. The battle was witnessed by Susan Clay and her children, who watched from Ashland's upstairs windows. (Courtesy of the University of Kentucky Department of Special Collections and Digital Projects.)

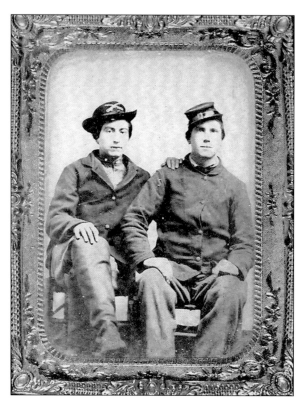

Jacob Wentzel (left) and John F. Meyers (right) served in the 4th Ohio Cavalry in the action at Ashland. They, like the rest of their Union unit, were completely surprised by John Hunt Morgan's brazen attack. (Courtesy of Kent Masterson Brown.)

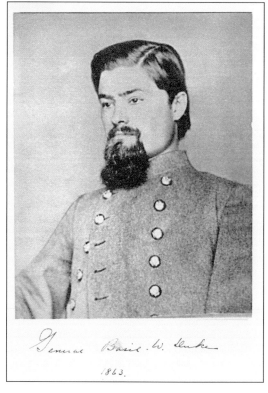

Basil Duke commanded a regiment of the Confederate 2nd Kentucky Cavalry for John Hunt Morgan. Duke's men attacked Union troops from the southwest to create a barrier between the Ohio cavalry and prevent escape into Lexington. To ensure that any escapees were captured, Duke sent two units into downtown Lexington. In addition to fighting in the battle at Ashland, Basil Duke recorded the experience in a book about Morgan and his raids. His account is the major source of information on this small but important engagement. (Courtesy of the University of Kentucky Library Department of Special Collections and Digital Programs.)

Col. Richard M. Gano led a Confederate battalion (later the 7th Kentucky Cavalry Regiment) into downtown Lexington via the Richmond Road, attacking the Ohio cavalry from the northeast. Gano formed a rear guard to protect the battalion in front of him. As can be seen in this image, Gano was quite the rakish figure. (Courtesy of the University of Kentucky Department of Special Collections and Digital Projects.)

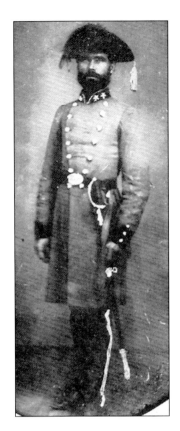

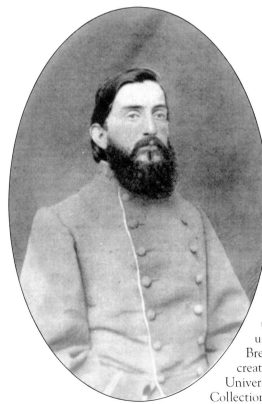

Col. W. C. P. Breckinridge led his Confederate battalion (later the 9th Kentucky Cavalry) along the Richmond Road in front of Gano's troops. Breckinridge's men dismounted and attacked the Union troops from the northeast. Embedded in his unit were two mountain howitzers (cannons) under the command of Sgt. C. C. Corbett. As Breckinridge attacked, the howitzers opened fire, creating great noise and confusion. (Courtesy of the University of Kentucky Library Department of Special Collections and Digital Projects.)

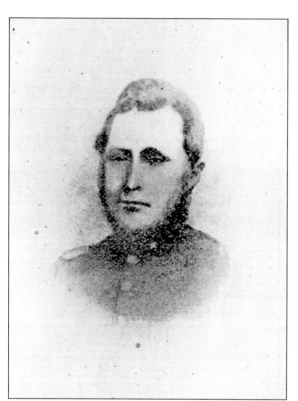

The action at Ashland on October 18, 1862, lasted about 15 minutes. In the battle, an unknown number of Confederates were wounded and killed, 4 Union troops died, 24 were injured, and 290 were captured. George Washington Morgan (shown here), John Hunt Morgan's cousin, was shot while riding across the lawn. Susan Clay provided a carriage to take George Washington Morgan to the Morgan home in downtown Lexington, where he died. (Courtesy of Kent Masterson Brown.)

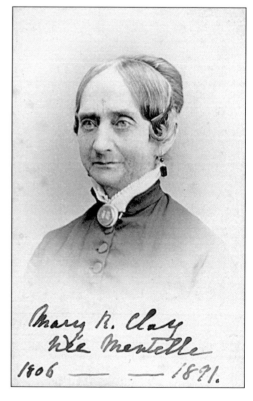

Shortly before the 1862 action at Ashland, James Brown Clay fled to Cuba and ultimately Canada. When James reached Montreal, he was dying of tuberculosis. By the middle of 1863, James summoned his wife. Before leaving, Susan rented the Ashland mansion to her sister-in-law, Mary Mentelle Clay (seen here), whose husband, Thomas, was ambassador to Nicaragua. James and Susan would never return to live at Ashland. (Courtesy of the Elizabeth Clay Blandford Collection.)

Three

OFF TO SCHOOL
The Kentucky
University Era

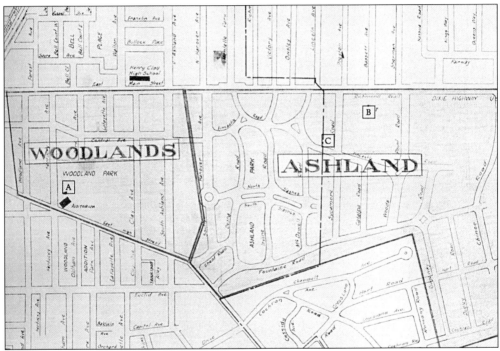

In 1862, a lesser-known congressman from Vermont named Justin Morrill made history by introducing an act that today bears his name. The Morrill Act allocated public land to states that were then obligated to sell it in order to generate proceeds for creating agricultural, mechanical, and engineering schools. The State of Kentucky set about selling its allocation and creating a college for its citizens that same year. After three years of wrangling, Kentucky finally passed an act establishing its agricultural and mechanical college, agreeing to merge it with the already existing Kentucky University (formerly Lexington's renowned Transylvania College). To create a campus for the agricultural and mechanical college, the state purchased two adjoining farms: the Woodlands, formerly the home of Henry Clay's daughter Anne, and Ashland. This map from *The University of Kentucky: A Pictorial History* by Carl Cone shows the two farms and some of the streets that now exist.

John B. Bowman

From Portrait by Brady.

Although Kentucky University was created by an act of legislature and consent of the Disciples of Christ Church, it was the brainchild of John Bryan Bowman. Bowman was the son of one of Kentucky's pioneering families and grew up in Mercer County. There he attended Bacon College, a small liberal arts college run by the Disciples of Christ. Bowman found his education satisfactory but was concerned by the fact that only relatively wealthy people could enroll. He also found the lack of curriculum pertaining to practical subjects, such as farming and manufacturing, troubling. Bowman ultimately became the president of Bacon College, remolding it to fit his belief in accessible, practical education. When a fire destroyed the college in 1864, Bowman merged the school with Transylvania University under the name Kentucky University. When the Morrill Act was passed, Bowman found the opportunity to fully develop his agricultural and mechanical school at Ashland. Through a merger with the state, Bowman finally created the school he envisioned, and Kentucky University opened in fall 1866 with Bowman as its regent. (Courtesy of Transylvania University Library Special Collections.)

In creating the merged Kentucky University, John Bryan Bowman established a governance structure in which he presided over Kentucky University as regent along with two presidents for the College of Arts and the Agricultural and Mechanical College. John Augustus Williams, shown here, was the first president of the Agricultural and Mechanical College when it opened in 1866. (Courtesy of Transylvania University Library Special Collections.)

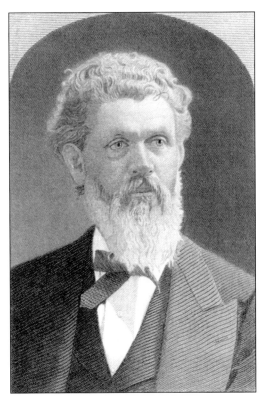

When, after only three years of service, John Augustus Williams resigned, he was temporarily succeeded by the man in this photograph, Joseph Desha Pickett. Not long after, Pickett was replaced by James Patterson. Patterson remained with the Kentucky Agricultural and Mechanical College into the 20th century, later becoming the first president of the University of Kentucky. (Courtesy of Transylvania University Library Special Collections.)

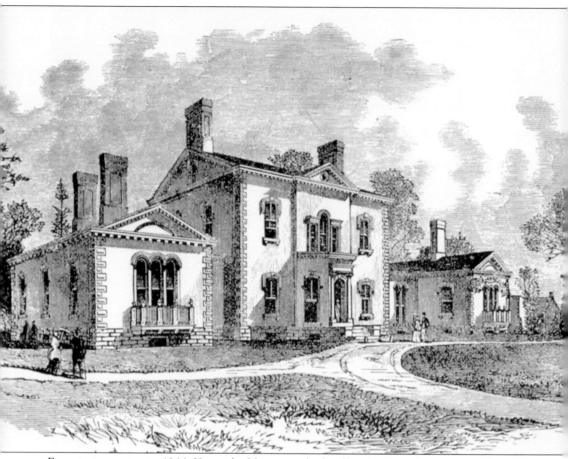

From its inception in 1866, Kentucky University had suffered serious financial problems. The State of Kentucky debated for such a long time over the university that by the time the land scrip was sold to fund it, its value had dropped significantly. Tuition was insufficient to cover operating costs. One expense the university did not have to meet was a salary for John Bowman. He refused to take the salary allocated him and instead accepted as compensation the right to reside in the mansion at Ashland. By 1867, Bowman and his wife had moved into the house. They lived and worked there and opened some areas of the house for events. This engraving shows Ashland as it appeared when John Bryan Bowman occupied it. (Courtesy of Transylvania University Library Special Collections.)

John Bryan Bowman was not the only unpaid employee of Kentucky University. His wife, Mary Dorcas Bowman, worked for the university voluntarily. Pictured here is a receipt for room and board received from M. P. Smith on Regent's Office stationery signed by Mrs. Bowman. It is one of a number of documents she handled as an unpaid secretary, registrar, and office manager for her husband. (Courtesy of Transylvania University Library Special Collections.)

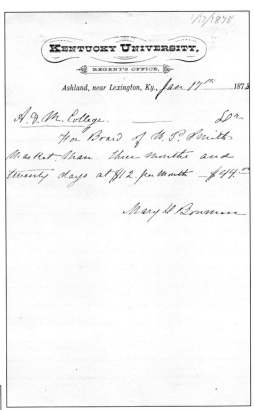

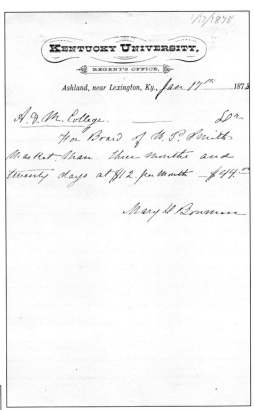

This is the letterhead for the Agricultural and Mechanical College. The document lists grades earned for the term ending January 24, 1879. Students could take courses from both the Agricultural and Mechanical College and the Arts College and were expected to complete work on both campuses. The fact that the two campuses were one and a half miles apart presented a challenge. (Courtesy of Transylvania University Library Special Collections.)

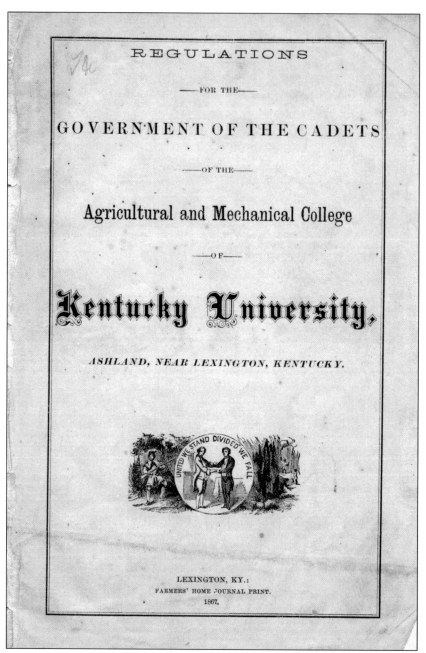

REGULATIONS

——FOR THE——

GOVERNMENT OF THE CADETS

——OF THE——

Agricultural and Mechanical College

——OF——

Kentucky University,

ASHLAND, NEAR LEXINGTON, KENTUCKY.

LEXINGTON, KY.:
FARMERS' HOME JOURNAL PRINT.
1867.

Some Kentucky University students chose to join the Cadet Corps, a program similar to today's Reserve Officer Training Corps programs. The corps resided at Ashland and was run similar to a military unit. Students wore uniforms, engaged in drills on the Ashland farm, and took courses in military studies. The cadets were governed by a strict code of conduct based on the Rules of Military Police and Discipline. Demerits were given for many offenses but could be offset by merits given for exemplary conduct. The cadets were organized into companies and ranked by class year as corporals, sergeants, or company officers. At graduation, successful cadets could be commissioned captains in the academic staff of the university. (Courtesy of Transylvania University Library Special Collections.)

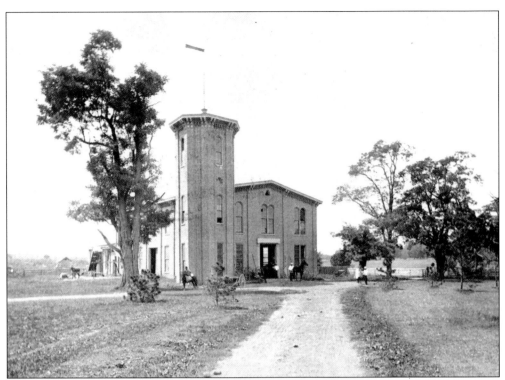

In 1867, John Bryan Bowman received as a gift the funds necessary to construct a mechanical building. G. Y. N. Yost, a Pennsylvania lawn mower magnate, asked students from the mechanical campus at Ashland to test his new mower. The students tested it and proved its worth. In return, Yost gave the school $25,000 to construct the building pictured here. This edifice housed laboratories, classrooms, and manufacturing facilities in which students could be taught the mechanical arts. (Courtesy of the University of Kentucky Department of Special Collections and Digital Projects.)

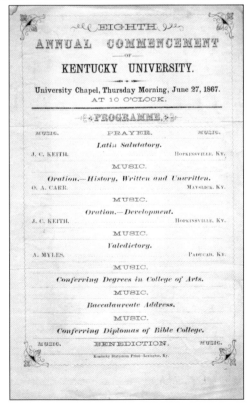

On June 27, 1867, Kentucky University held its commencement on the Arts College campus. Since the Agricultural and Mechanical College had been open only a year, no degrees were conferred by it. The first graduate of the Agricultural and Mechanical College graduated in 1869. (Courtesy of Transylvania University Library Special Collections.)

Account of Addytions made to the Museum
since January 4th 1867.

Prof. R. Peter
Hooded Merganser (Lophodytes cucullatus)
— male — Skinned by A.W.

Prof. R. Peter
Muskrat (Fiber Zibethicus) skinned by A.W.

Washington Eagle (Haliaetos Washingtonii) skinned
by A.W.

A. Winchell
Skull of Field mouse (Arvicola riparia) Prepared
by A.W.

W. Thamp, Millersburg, Ky
Skin of Washington Eagle (Haliaetos Washingtonii)
Spread of wings 7 ft 4 in (Express $1.00)

Regent J.B. Bowman
Sparrow Hawk (Falco sparverius) Skinned
by Dunlap (J.M.)

A. Winchell
Skeleton of Sparrow Hawk, except head and limbs
Prepared by A.W.

J.J. Nesbitt (Student)
Skull of Hare (Lepus sylvaticus) Prep. by Nesbitt

Bowman Williams
Belosoma Haldemanum

John Bryan Bowman's vision of education included more than classroom instruction. He believed students would benefit from other forms of education, such as musical recitals, plays, lectures, libraries, and museums. In keeping with this view, Bowman set aside an area of his residence at Ashland to house a natural history museum. It would include a collection of anything which might be interesting or informative and run according to the latest professional standards. On January 3, 1867, Bowman hired A. Winchell, professor of natural history, and assigned him the task of organizing the museum. Bowman allocated funds from the salary he never accepted to help pay for the museum and negotiated deals with the Smithsonian Institution, among others, to bring surplus collections there. Very quickly, the museum grew to include over 20,000 specimens. (Courtesy of Transylvania University Library Special Collections.)

The collection of the Museum of Natural History at Kentucky University contained an amazing array of artifacts. It exposed students to as much scientific knowledge as possible through biological, anthropological, and historical specimens. The collection pictured here includes cultural material from Asia. The armor is identified as Korean, but recent research indicates it may be Japanese. The fibrous material is from Fiji and is a type of armor. (Courtesy of Transylvania University Library Special Collections.)

The majority of the collection was biological, consisting of preserved plant and animal specimens. Birds made up a large part of the animal collection and were mostly foreign in origin. As can be seen in this picture of the collection, after it was relocated to Transylvania, exhibition meant displaying everything rather than selected material in order to explain a concept or idea. (Courtesy of Transylvania University Library Special Collections.)

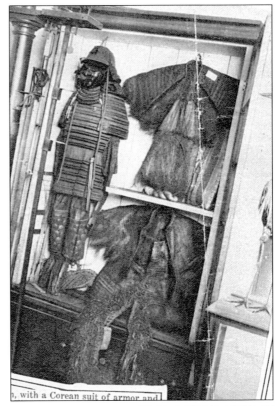

, with a Corean suit of armor and

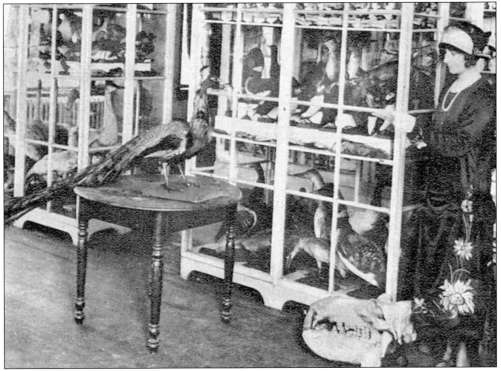

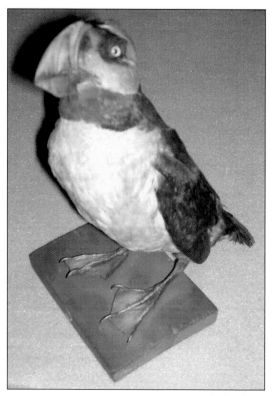

John Bryan Bowman expended a great deal of effort securing donations to his museum. One of the most important donors Bowman courted was the Smithsonian Institution. He was able to convince the secretary and assistant secretary of the Smithsonian to share its wealth of material and to include Kentucky University in its collecting expeditions. This Atlantic puffin was part of a collection of North American birds donated to the Kentucky University Museum on June 8, 1872. (Courtesy of the Moosnick Museum of Transylvania University.)

This yellow tanager is another Smithsonian Institution donation. It was collected on April 6, 1864, in Costa Rica and given to the museum as part of a collection of Costa Rican birds. (Courtesy of the Moosnick Museum of Transylvania University.)

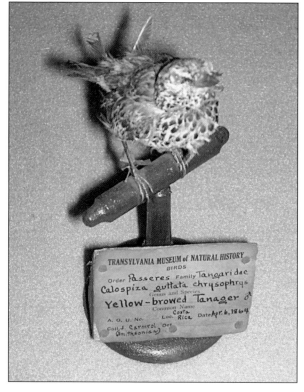

The museum at Kentucky University received donations from a number of sources in addition to the Smithsonian. Most artifacts were gifts of individuals in the community or people who were connected with the university in some way. This carved coconut was a gift of Henry Clay's son Thomas. He probably collected it while serving as ambassador to Nicaragua or Honduras. Thomas grew up at Ashland and his son Thomas Jr. attended Kentucky University. (Courtesy of the Moosnick Museum of Transylvania University.)

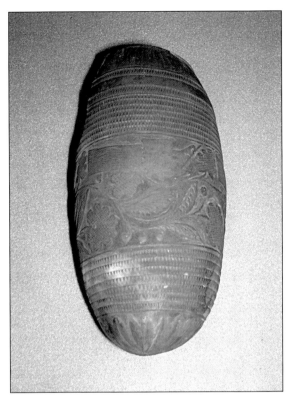

Another area of collecting for the museum was archaeological material. There were large quantities of arrowheads, spear points, utensils, and other material. Unfortunately, information about tribal affiliation, or place of excavation, was rarely recorded. All that is known about the Native American spoon pictured here is that it was found and donated by J. W. Wilson in March 1869. (Courtesy of the Moosnick Museum of Transylvania University.)

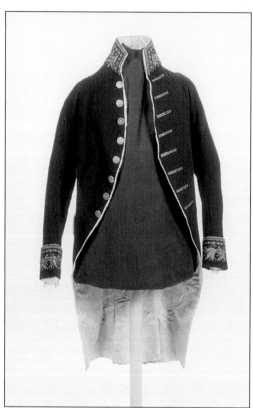

Historical material was also included in the collection of the Kentucky University museum. A piece of Martha Washington's wedding dress, Civil War bullets, a lance from the Mexican War, and a 1765 Stamp Act document were part of this collection. This coat belonging to Henry Clay was given to the museum by his grandson James Brown Clay Jr. in 1872 or 1873. (Photograph by Mary Rezny.)

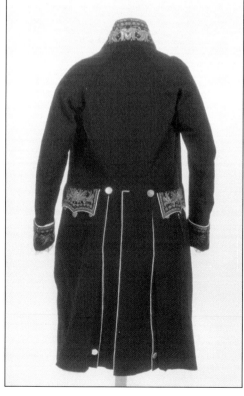

This is the rear view of Henry Clay's coat. He is believed to have worn it at the signing of the Treaty of Ghent in 1814, and it likely was issued by the government for use at official occasions. It is the only artifact in Ashland's current collection known to have been exhibited in the Kentucky University museum. (Photograph by Mary Rezny.)

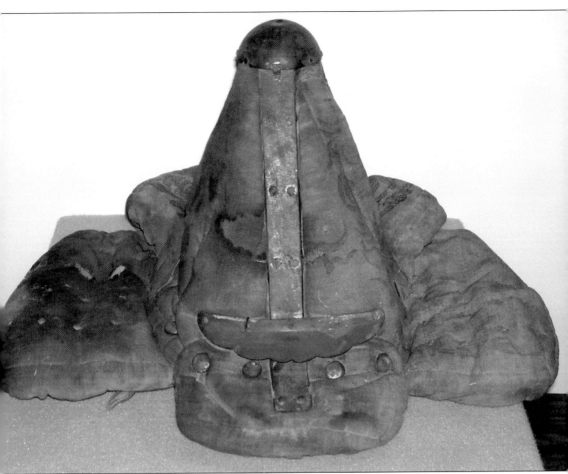

This Korean helmet is another item from the historical collection of the Kentucky University museum. It was brought to Kentucky accompanying the body of Lt. Hugh McKee, a naval officer from Lexington who had been killed in an American attack on a Korean fortification in 1871. McKee was the first American to die on Korean soil, and the action in which his death occurred caused a major diplomatic rift between the United States and Korea that lasted for many years. McKee died valiantly and would have been a candidate for the Medal of Honor had naval officers been eligible for it at the time. McKee's body was returned to Lexington along with this helmet, a small cannon, and several matchlock rifles. The helmet was donated to the museum by McKee's mother, Jane McKee Jones, to serve as a reminder of his service and sacrifice. (Courtesy of the Moosnick Museum of Transylvania University.)

KENTUCKY UNIVERSITY.---A REMONSTRANCE.

To the Senate and House of Representatives of the Commonwealth of Kentucky:

Your petitioners, citizens of Lexington and Fayette County, and many of us donors to Kentucky University, would most respectfully represent to your honorable bodies, that of six hundred and odd thousand dollars, the present pecuniary worth of Kentucky University, without including the Agricultural Fund of one hundred and sixty-five thousand, at least one-half has come from the County of Fayette, either by the individual contribution of its citizens, or by the cession of the funds and property of Transylvania University, in which they all collectively have an interest; and that, therefore, all that may retard or promote the growth of Kentucky University, all that may contract or extend the sphere of its usefulness, is to us a matter of deep and permanent concern. Indeed, we go further, and represent that if not one of us had ever contributed a dollar, either directly or indirectly, to this great charity, we should still not remain indifferent spectators of its fortune; but, on the contrary, we should ever heartily desire that the most liberal and enlightened policy might continue to direct its management, to the end that hundreds of students might annually be attracted to its halls, both to advance the prosperity of our city and to diffuse as widely as possible the manifold blessings of knowledge, morality and virtue over our common State and country. On this subject, then, we feel that we have a right to speak in tones of potent emphasis; and so, reposing, as we do, all confidence in your wisdom and justice, we do now and here MOST EARNESTLY PROTEST AND REMONSTRATE AGAINST ANY CHANGE IN THE CHARTER OF KENTUCKY UNIVERSITY, and for the following reasons—

1. Because the consolidation of Transylvania with Kentucky University, and the private donations here made to the latter, were made on the repeated pledge and distinct understanding that the new institution of learning was to be established on a broad and liberal basis, and that it was not to be controlled in the exclusive interest of any church or sect or party. On the contrary, if, before the union of the Universities, any such policy had been announced for the government of the combined institutions, is now openly and avowedly seeks to control it, most assuredly our consent to the combination would never have been given, and our prompt and generous contributions would never have been made.

2. Because, in order to secure near our city the location of the Agricultural College, our citizens contributed in 1865 more than one hundred thousand dollars to purchase a site for it and the other Colleges of the University, and the severance of the that binds the Agricultural College to the University would lead at once to bitter and interminable strife, inasmuch as we should regard it as outrageously unjust to lose not only the Agricultural College, but the very large sum that we gave to secure its location. That such would be the inevitable and immediate result of the disruption, is shown by the fact that those who are doing their utmost to bring that disruption about, already boldly and publicly claim that the large and valuable estates on which the Agricultural College is now located, are and must remain the property of their donors, on the ground that the title to them is vested in the Curators of Kentucky University. To cut off the Agricultural College would be a violation of a solemn compact between the State and the University; to keep our money for a purpose for which it would never have been given, would be the consummation of iniquity.

Earnestly desiring to end an unprofitable controversy, and to unite and retain as many as possible in support of the University, we wish its charter to remain precisely as it stands, even with that provision unchanged which gives to those who have done relatively so little for the University so large a voice in its councils. The conspicuously able and successful management which for eight years has annually presided in the classes of the University from five hundred and fifty to nearly eight hundred students, has conclusively shown how signally the institution may continue to prosper, if directed by the same wise and generous policy. It shall still appeal to the sympathy and support of ALL, and be kept elevated high above all the distinctions and the prejudices of sect or party, creed or latitude. But if, in violation of well-defined and most important trusts; if, in disregard of the emphatic and reiterated pledges under which the money of our people was so freely given, the University is likely to become solely subservient to any ecclesiastical interest, or be used to further the ignoble ends of any narrow and proscriptive sect or faction, then we shall at once insist that the dictates of exact and even-handed justice will require, Nor that a body, a few of whose members have contributed less than one-fourth of the property of the University, shall exclusively control the whole, but that all the several interests involved shall be allowed a proportionate and equitable representation in the Board of Curators.

That your honorable bodies may concur in the object of this remonstrance, your petitioners do now and shall ever pray.

The above Remonstrance (the originals on file with the House Judiciary Committee) is signed by a large number of the prominent and leading citizens of Fayette County, of all parties, political and religious, including a majority in interest of the Donors to the University, from said county, and embracing such names as the following:

E D Sayre	Henry Bell	I P Straus & Bro	M Kauffman
Benj Gratz	Jas W Sullivan	W W Boyd	Augustus Clark
W M Fishback,	Jno B Wilgus	C V Cowgill	Thos Wheatley
Jno B Payne, Jr	R B Hamilton	Thornton Moore	Walter B Beard
Jos Hoeing	A Walrath	Frank & Fred Fitch	E Brennan
H Shaw	Geo W Norton	T J Bush	w S Lipscomb
Jno S Wilson	Isaac W Scott	R P Stoll	R D Craig
Col W C P Breckinridge	Maj B F Buckner	E J Curley	Col Jo H Tompkins
Dr W S Chipley	Geo W Brand	G E Billingsley, Esq	J W Cochrane
Geo Stoll, Jr	J P Shaw	Walter Scott	E Cosby
Wm Holloway	H A Guthrie	W F Warren	E Warren
Jas A Grinstead	Wm B Kinkead	Wm Mullaney	W H Newberry
J B Sharpe	Dr A S Talbott	Chas Mills	Mary R Simpson
Judge R A Buckner, (not a subscriber to the University)	J M Elliott	Chas Schultze	Wm Walker
P C Hollingshead	Jno T Miller	Judge Speed & Goodloe	J F Johnston
W R Milward	Jos Milward	Dr L P Tarlton	E E Eagle
J M Tipton	W Frazer	C B Ross	Henry C Brennan
S Swift	Mrs J B Clay	Joseph Timmins	E R Spotswood
C W Headley	Isaac Hutchison	W L Threlkeld	W J Tweedie
Jno Hutchison	B T Milton	J Soule Smith, Esq	B F Williams
Jo Clark	G D Wilgus	Jno B Overton	F W Woolley
M P Lancaster	Isaac C Vanmeter	J G Hamilton	Sam P Barr
A B Lancaster	Mrs Martha Reed	Wm A Poindexter	D Knoble
Thos Mitchell	Jos S Woodruff	Jno Cornelison	Jas F Drake
Thos P Dudley, Baptist Minister	Rich'd Valentine, Presb. Minister	Thos B Megowan	T H Shelby
Wm Dinwiddie, Pastor 1st Presb. Church	L B Woolfolk, Pastor 1st Baptist Church	Judge J H Mulligan	Benj Mills
G E Strobridge, Pastor Centenary M E Church	J S Shipman, Rector of Christ Ch.	D Burbank	J Caldwell Curd
J H Bekkers, Minister St. Paul's Catholic Church	J Rand, Pastor M E Ch. South	Wm K Fleming	W A Gunn
E Y Pinkerton, Minister Christian Church	R T Dillard, Baptist Minister, and late Supt. Pub. Instruction	G M Adams	W Talbott
Jno C Freeman, Pastor Glen's Cr'k and S. Elkhorn Baptist Chs	Rutherford Douglass, Presb. Minister, Pastor Pisgah Church	R P Bosworth	Hugh W Adams
J L Smith, Baptist Minister	Seneca H Hall, Presiding Elder, Harrodsb'g Dist. M E Ch. South	Jno Parker	S J Salyers
W S Goodloe, Pastor Presbyterian Church, Mt. Sterling	E S Duncannon	Jas C Butler	Jno Curd
Jno M Bell	Robert Ryland, D D, Baptist Minister.	Geo F Garnahy	Ben S Drake
S Bacon	Gen Jno B Huston	Phil F Brown	E C Kidd
Chas Y Bean	J T Davidson	Samuel F Gray	Geo C Snyder
D Mulligan	A F Hawkins	W E Bosworth	Edward Pendleton
Dr J P Letcher	Dr J M Bush	Isaac P Shelby	Wm Purnell
Dr J M Bruce	Dr J W W Whitney	Jno Thorns	Dr Jno W Scott
Wm Campbell	Horace G Craig	J B Norton	Edwin R Drake
Y B Wood	A M Barnes	W F Hughes	J B Rodes
R de Roode	P Scott	Wm Dow	Jno Dow
Dr Stoddard Driggs	M G Thompson	Wm Christie	Capt O P Beard
Jno C Young	Z Gibbons, Esq	Wm L Neale	D G Falconer, Esq
Thos Bradley	J H Harrison	A H Adams	Jno O Hodges, Jr.
J A Higgins	W Harting	B Bell	T J Pilcher
E Siebrecht	Judge C D Carr	B Green	E J Turner
Jos Hollenkamp (signed the counter petition, not understanding its object)	J J Hunter	C T Messick	Geo B Kinkead, Jr. Esq
J W Cannon	James Mullen	Jno Goers	R McClanahan
P E Yeiser	H Hardesty	A J White	P J Lamphear
S De Long	M Goldsmith	Geo H Kinnear	Dr L B Todd
J U Milward	A Pilkington	G W Bosworth	W B Cooper
J B Roddick	J G Cowan	P S Rule	Maj H B Mc'Lellan
H E Dowden	Thos Norris, Sr	E P Shelby	Wm Warfield
P E Thompson	Col P Burgess Hunt	W D Johnson	W T Nichols
H T Duncan, Sr	Geo Woolley	Chas & Williams	Samuel R Smith
Jno Duncan	wm McCracken	P C Kidd	Geo W Darnell, Esq
S W Price, P M	Wm Van Deisen	Geo W Stewart	Dr G B Buckner
N P Cochran	W W Monroe	R H Courtney	E A Thornton, Esq
Jno T Bruce	James Dudley	Geo Stoll	James Brennan
Jno H Werts	Daniel Walde	G C McMurtry	Geo W C Graves, Presiding Judge Fayette County Court
P F Maguire	H M Buford, Esq	Wesley Spencer	Gen D s Goodloe
John C Trotc	Henry Wolf	S A Schoonmaker	Jno Kastle
Mary E Carty	M Pruden	W B Till	J R Morris
Allie G Hunt	S S Thompson	H A Bowne	Levi T Rodes
Jno T Lyle	G W Ranck	Geo Lancaster	H Gilbert
Jno G James	J G Frazer	Sam M Faris	H C Bowman
	Joseph Wasson	W W Johnson	H C Bowman, as Trustee for Abraham Bowman
		Sallie H Woolfolk	R H Stanhope
		Wm F Stanhope	W C Stanhope
		M M Mitchell	J B Wasson
		B B Cooper	Jno H Woolfolk
		Rev J A Davis	Mrs D Barrow,
		Mrs M Harris	and many others.
		Jno G James	

Kentucky University was, from its beginning, a marriage of two distinct entities having separate goals and objectives. As might be expected under such circumstances, there was friction almost immediately between the Disciples of Christ Church and the State of Kentucky over how the university should be run and who should have power. For a while, John Bryan Bowman was able to bridge this divide, but as time passed, it grew wider until he was personally drawn into the rift. Considerable effort was exerted to change the original charter of the institution and to separate the two signatories. Many felt this was an abuse of the public monies and trust that had been used to create the institution. Citizens signed this petition against changing the charter in any way. Interestingly one of the signatories to the petition was Susan, widow of James Brown Clay, who in 1866 had sold Ashland to John Bryan Bowman to be a campus of Kentucky University. (Courtesy of Transylvania University Library Special Collections.)

AN ACT IN RELATION TO THE AGRICULTURAL AND MECHANICAL COLLEGE OF KENTUCKY, AND TO PROVIDE FOR THE FUTURE MANAGEMENT AND LOCATION THEREOF.

WHEREAS, The Joint Committee appointed by this General Assemby to investigate the condition and relations of the Agricultural and Mechanical College, has reported recommending the severance of the connection existing between said College and the Kentucky University; and whereas, it is desirable to continue the operations of said College until the same is permanently located and established, provided satisfactory arrangements can be effected as is hereinafter provided; and whereas, the future location, establishment, and success of said College is a matter of great and common interest to the people of the whole State, and which should be the pride and aim of every citizen having the future prosperity and welfare of the Commonwealth at heart; therefore,

§ 1. *Be it enacted by the General Assembly of the Commonwealth of Kentucky*, That so much of the act approved February 23, 1865, entitled "An act establishing the Agricultural and Mechanical College of Kentucky as one of the Colleges of the Kentucky University," as established the Agricultural and Mechanical College of Kentucky one of the Colleges of the Kentucky University, and so much of said act as places said Agricultural and Mechanical College under the control of the curators of the Kentucky University, and as allows said curators to receive the interest on the fund arising from the sale of land scrip granted to the Commonwealth of Kentucky by act of Congress, approved July 2, 1862, be, and the same is hereby, repealed, said appeal to take effect the first day of July, 1878.

§ 2. There is hereby appointed and constituted a commission, to be styled "The Agricultural and Mechanical College Commission," composed of the Lieutenant Governor of the Commonwealth of Kentucky, who shall be *ex officio* a member and the chairman of said commission, and J. M. Bigger, of the First Congressional District; James Weir, of the Second Congressional District; C. U. McElroy, of the Third Congressional District; David R. Murray, of the Fourth Congressional District; J. Lawrence Smith, of the Fifth Congressional District; H. P. Whitaker, of the Sixth Congressional District; R. A. Spurr, of the Seventh Congressional District; M. C. Saufley, of the Eighth Congressional District; D. D. Sublett, of the Ninth Congressional District, and Richard Dawson, of the Tenth Congressional District. Said commission are hereby authorized and empowered, and it shall be their duty, to provide, if possible, for the continued operation of said Agricultural and Mechanical College, and to make such equitable and just arrangements with the authorities of Kentucky University as will secure such advantages of an interchange of students, the use of buildings, apparatus, land, &c., as will secure the continued existence and prosperity of said Agricultural and Mechanical College until the same is finally located and settled; and in case said commission should not be able to make such satisfactory arrangements with Kentucky University as is equitable and just, and such arrangements as will secure the best interest of the Agricultural and Mechanical College, they may suspend the operations of the Agricultural and Mechanical College until the same is finally and permanently located, as hereafter provided. Said commission are empowered, and it shall be their duty, to advertise for and receive proposals and offers from counties, towns, or cities, or non-sectarian institutions of learning, in lands, buildings, money, apparatus, &c., or either of them, for the permanent location of said Agricultural and Mechanical College; and after receiving said proposals and offers, they shall report the same to the next regular session of the General Assembly, and shall recommend that place which shall present the best and greatest inducements, all things considered; and any offer or proposal, when made to, and confirmed by, said General Assembly, shall be final and binding; and said commission, in making advertisements for the proposals, and in the reception thereof, shall make it a condition precedent that all proposals shall be binding if accepted by the General Assembly. Said commission, in effecting an arrangement for the continued operation of said Agricultural and Mechanical College until the same is permanently and finally located, or in receiving proposals for its final location, shall be empowered to adjust and settle all outstanding differences that may exist between the Agricultural and Mechanical College and Kentucky University; and if said differences are not thus adjusted, said commission may adjust and settle same in such other manner as may be just and equitable. Said commission are also empowered to take such steps as may best further the interest of said Agricultural and Mechanical College, and secure its successful management and operation, not inconsistent with the provisions of this act.

§ 3. Said commission shall ascertain the number of departments of study necessary for the effective operation of a first-class State University, such as the geographical condition of the Commonwealth, her agricultural and mineral resources, her influence and dignity, require to be constituted for the education of her sons; the plan of organization, salaries of professors and instructors, the plan, cost, and equipment of college buildings, experimental farm, mechanical department, horticultural department, laboratories, museums, and cabinets, and to report the same to the next regular General Assembly.

§ 4. Said commission shall determine how many of its number shall constitute a quorum (which shall not be less than a majority) for the transaction of business, when and where their sittings shall be held, with all other matters competent to the discretion of committees; and it shall be the duty of the said chairman to call a meeting of said commission for the transaction of business, or a meeting

By 1878, John Bryan Bowman could no longer hold Kentucky University together. The board of curators, who had been blocked by the faculty from firing Bowman, finally voted to abolish his position and dissolve the institution. This act of the legislature, dated July 1, 1878, formally dissolved the partnership between the Disciples of Christ and the institution known as Kentucky University. The Disciples of Christ kept the Kentucky University name, using it until the early 20th century, when their institution readopted its original name: Transylvania University. The state vacated Ashland and the adjoining Woodlands farm and relocated the Agricultural and Mechanical College to the old city fairgrounds, where it operates today as the University of Kentucky. (Courtesy of Transylvania University Library Special Collections.)

Woodlake, Franklin Co., Ky. Apl 26 1882

My dear General

If it had not been for my wife's desire to have Ashland I should have withdrawn my offer this morning — Since my return I have talked the matter over with her and I find that she will not be so much disappointed as I had supposed — I therefore withdraw the offer —

Now, as we are now both acting under a mistaken view of the facts, I pro-pose this compromise — I will give $60.000 for the place, payable as agreed —

If this will not purchase it I am no longer an applicant —

The most probable purchaser for my place has to be secured, if at all, without delay — I am therefore

After renting the Ashland estate for several years, the Board of Kentucky University divested itself of the property. The board put the farm up for sale and quickly drew the interest of Maj. Henry Clay McDowell of Frankfort, who was married to Henry Clay's granddaughter Anne Clay. McDowell began to negotiate a price and in this letter issues his final offer of $60,000. (Courtesy of Transylvania University Library Special Collections.)

After several months of negotiation, the Board of Kentucky University agreed to the sale of the Ashland estate to the McDowells for $60,000. This agreement was executed on May 13, 1882, and the McDowells took possession on January 15, 1883. After 17 years, Ashland was a Clay family farm once again. (Courtesy of Transylvania University Library Special Collections.)

Four

BACK IN THE FAMILY
The McDowell Era

When Major and Anne Clay McDowell purchased Ashland, they did so to return Anne's ancestral home to family ownership. Upon moving into Ashland in January 1883, they found a farm that had not been well maintained for two decades. The Civil War and years of ownership by a struggling university had taken their toll. The McDowells set about modernizing the house and farm and soon would make it a center of Lexington society. This photograph shows Ashland as it appeared not long after the McDowells acquired it. They had added the awnings and significantly refurbished the house and grounds by this time.

By the time Maj. Henry Clay McDowell—age 51 in this *c.* 1885 cabinet card—purchased Ashland, he was a wealthy businessman. He had succeeded in ventures including printing, banking, and railroads, establishing himself as a leader of Lexington and Kentucky society. Major McDowell would again make Ashland a Lexington landmark and an equine showplace. (Courtesy of the University of Kentucky Library Department of Special Collections and Digital Projects.)

Major McDowell's wife, Anne Clay McDowell, was the daughter of Henry Clay's son Henry Clay Jr. When she took up residence at Ashland, she was 46 years old and the mother of seven children. Anne had recently lost her youngest son in a horrible accident involving a fire in the family's Frankfort home, and Ashland was a sanctuary after this tragedy. (Courtesy of the University of Kentucky Library Department of Special Collections and Digital Projects.)

This image shows the formal garden as it appeared when the McDowells acquired Ashland. The garden, like much of the estate, had been poorly maintained. The couple ultimately returned the formal garden to the splendor of Henry and Lucretia Clay's era. (Courtesy of the University of Kentucky Library Department of Special Collections and Digital Projects.)

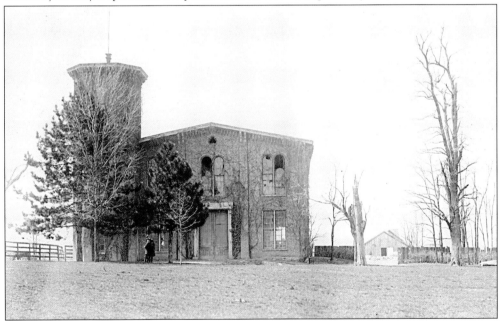

One of the legacies of Kentucky University that the McDowells acquired was the large mechanical building erected in 1867. Major McDowell tore out the classrooms and laboratories and installed horse stalls and a circular training track, creating one of the best indoor equine facilities in Lexington. (Courtesy of the University of Kentucky Library Department of Special Collections and Digital Projects.)

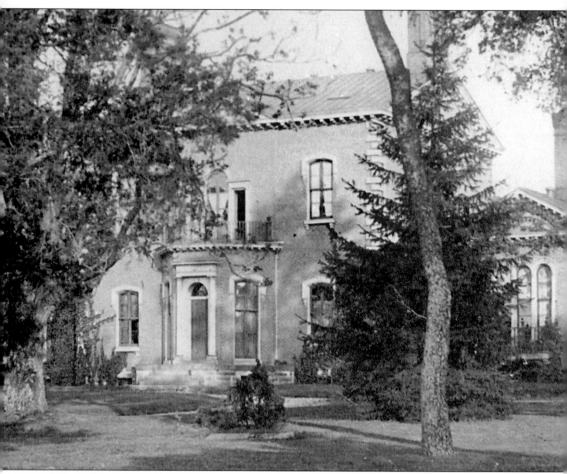

When the McDowells purchased Ashland, its location, approximately one and a half miles from Lexington, prevented them from connecting to the municipal gas system. In order to light the house, the McDowells decided to install their own gasworks, selecting a Springfield Gas Machine. This type of machine was the most expensive, best available, and used in the finest houses around the country. It had an outdoor tank located in a brick vault and used a system of stone weights to pump air over gasoline-filled trays. The mixture of air and gasoline vapor traveled through pipes to light fixtures installed throughout the house by the McDowells. This photograph shows the mansion, a shrub located in the center, and the doors to the gasworks vault visible in front. (Courtesy of the University of Kentucky Library Department of Special Collections and Digital Projects.)

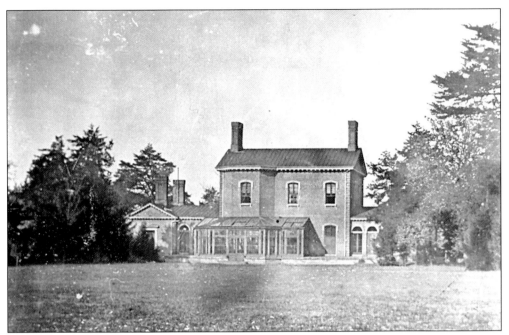

Another change the McDowells made to Ashland was the addition of a conservatory. The structure, seen in this early photograph of the back of the house, was a glass sunroom added on the terrace. It was accessible through both the parlor and dining room and served as extra space for entertaining and relaxation. The family kept it continually filled with plants, particularly palms.

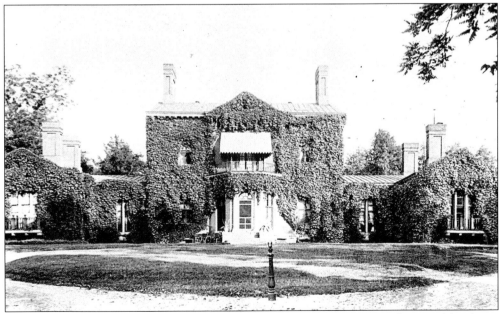

The McDowells made many other changes to the house in their desire to bring Ashland into the most modern and fashionable style. To document these changes, the McDowells created a photograph album in 1897. The album captured in vivid detail the way the house was decorated and used by the family. This photograph is the first in the album and shows the front of the house covered in ivy.

This photograph from the McDowell album is of the stairwell in the main entry hall. The McDowells replaced the original spiral staircase with this oak Eastlake design. It was an aesthetic as well as practical decision as the straight staircase was easier to negotiate and admitted more light into the house through the front windows. In addition, the McDowells removed an interior wall that had separated the stairwell from the rest of the entry hall.

This image from the McDowell album shows the left side of the entry hall opposite the stairs. The doorway into Major McDowell's study was located opposite an original stairwell door that the McDowells removed. The tall case clock, to the right of the door, was a gift to Major McDowell from an organization of printers of which he was a member, who visited Ashland in 1891.

The McDowells were very sociable and entertained often. This photograph from their album shows the parlor where they often welcomed guests. They added the silver gasolier hanging in the center of the room and may have added the ceiling medallions and trim. The McDowells were also a very musical family and enjoyed the piano and guitar pictured in this photograph.

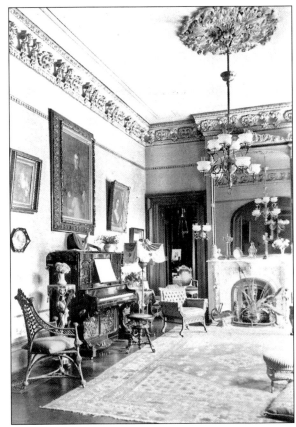

Another change the McDowells made was to relocate the dining room, moving it to what had been the back of a double parlor. They converted the old dining room into a butler's pantry and installed a bathroom in the adjoining passage, using modern indoor plumbing. The centerpiece of the dining room was this table and chairs, passed down through Major McDowell's family. The large safe was used to protect documents from fire and could be rolled out of the house in an emergency.

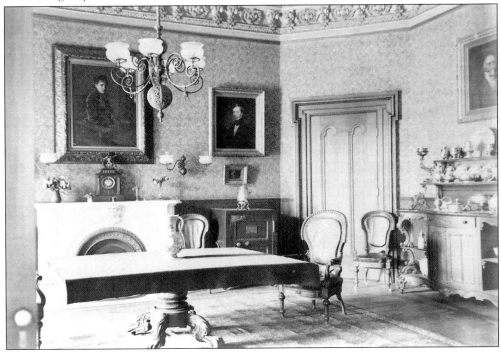

The sideboard pictured here is also out of the McDowell dining room. Much of the silver displayed remains at Ashland today. The identity of the man in the painting above the sideboard is a mystery. The decorative treatment on the lower half of the wall is called Lincrusta, a covering made of pressed sawdust and linseed oil that is similar to linoleum and was invented by the same person.

This photograph from the McDowell album looks through the library into what is now the billiard room. The domed library was originally designed by Benjamin Latrobe for Henry Clay's Ashland, and either Henry Clay's son James or the McDowells later added the paneling and ribbed ceiling. The McDowells added a serpentine light fixture and gasolier when the gas system was installed about 1887.

This room was used for a variety of purposes but primarily by Major McDowell and seems to have been part study, part relaxation area. The moose head and the pheasant (called "Fezzie"—a longtime fixture at Ashland) are evidence of Major McDowell's interest in big game hunting. He belonged to the preeminent hunting society of the day, called the Boone and Crockett Club. One of the people Major McDowell became acquainted with through his membership was Theodore Roosevelt, who visited Ashland in 1895.

This final photograph in the McDowell album shows the interior of the conservatory that was added to the rear of the house. It was filled with plants, used as a greenhouse, and became a favorite place for the family to gather, as evidenced by the many pictures of them taken in this room. The wire furniture remains at Ashland today.

Julia - Nettie - Madge

Along with Major and Mrs. McDowell, three primary residents of Ashland were, from left to right, daughters Julia, Nannette, and Madeline. When the family moved in, Nannette was 23, Julia, 14, and Madeline, 11, and the girls remained at Ashland until they married. The McDowell girls were very popular, socially active hostesses and kept Ashland alive with parties and gatherings of friends and suitors. All three would ultimately hold their weddings at Ashland. (Courtesy of the University of Kentucky Library Department of Special Collections and Digital Programs.)

In addition to their three daughters, the McDowells had four sons, one of whom had died before they moved to Ashland. This photograph is of the McDowells' youngest surviving son, Thomas Clay, pictured with his mother. He was the only son to remain at Ashland, ultimately building a house near the northwest corner of the estate. (Courtesy of the University of Kentucky Library Department of Special Collections and Digital Projects.)

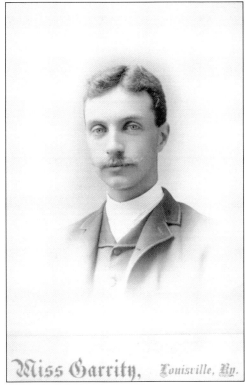

The McDowells' second son, William Adair McDowell, was attending Yale when the family moved to Ashland, but he returned home shortly thereafter. William resided in Lexington and became a businessman working in banking and railroads like his father. (Courtesy of the University of Kentucky Library Department of Special Collections and Digital Projects.)

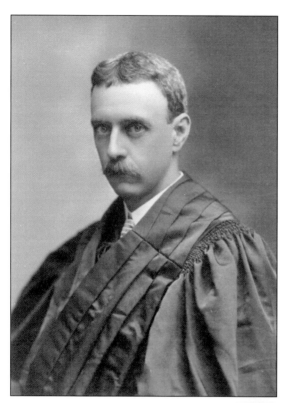

The McDowells' eldest son, Henry Clay McDowell Jr., was also away at school when they moved to Ashland. He attended Yale and the University of Virginia School of Law, ultimately practicing law in Big Stone Gap, Virginia. As can been from this picture, he later became a judge of the U.S. District Court. (Courtesy of the University of Kentucky Library Department of Special Collections and Digital Projects.)

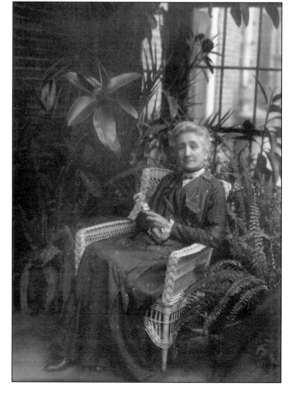

One of the most interesting women to reside at Ashland was Major McDowell's unmarried sister, Magdalen Harvey McDowell. "Aunt Mag," as she was called, was an artist, architect, and inventor. She designed several buildings throughout Lexington and elsewhere and patented a heating system for use in a fireplace. As a woman living outside of traditional roles, Aunt Mag exerted a profound influence on her nieces. (Courtesy of the University of Kentucky Library Department of Special Collections and Digital Projects.)

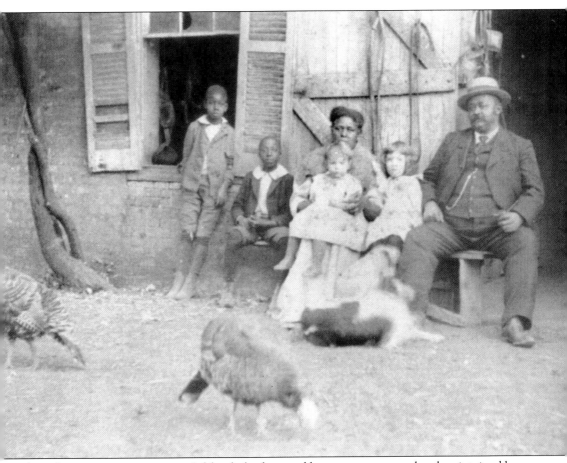

As with previous generations at Ashland, the farm and house were managed and maintained by African Americans during the McDowell era. Because slavery had ended 17 years before they acquired Ashland, the McDowells hired their help. This photograph shows two of the hired servants, Bob and Agnes Holton. Bob drove the carriages and, later, cars, and Aggie cooked and cared for the children. The two African American children in this picture are unidentified, but the other children are McDowell grandchildren. (Courtesy of the University of Kentucky Library Department of Special Collections and Digital Projects.)

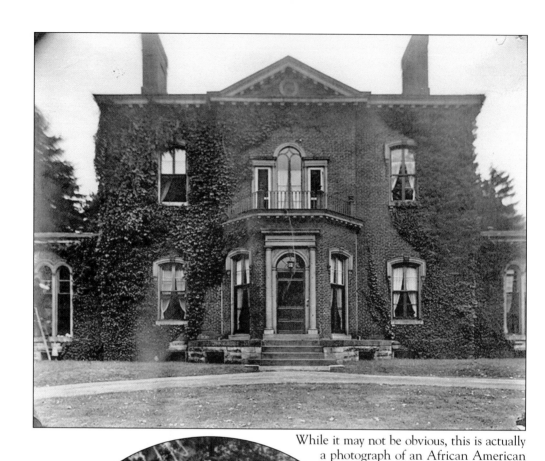

While it may not be obvious, this is actually a photograph of an African American at work at Ashland. He is to the far left, standing on a ladder cleaning windows. His identity is unknown. (Courtesy of the University of Kentucky Library Department of Special Collections and Digital Projects.)

The woman in this picture is Agnes Holton. She is doing something she often did: taking care of the children. The child on the horse is William Cochran McDowell, son of William Adair McDowell. The McDowells' grandchildren often stayed at Ashland, and Agnes usually cared for them. The African American youth in this picture is unidentified.

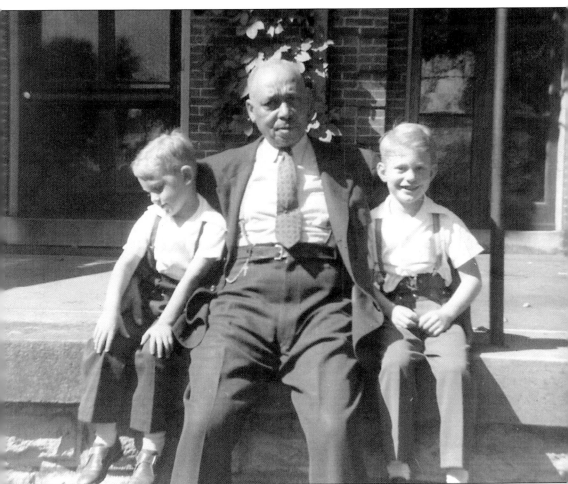

Thomas Hummons, the African American gentleman in the center of this photograph, was one of the longest-serving workers employed by the McDowells. He came to Ashland in 1895, at about 18 years of age, to replace his brother Henry, who was leaving for college to study medicine. For the next 53 years, Hummons worked as a driver and valet, and during that time, his daughter Myrtle often visited. She ultimately attended Wilberforce College and was trained as a teacher. Thomas Hummons remained at Ashland until Nannette McDowell Bullock died in 1948, and her will stipulated that he receive a pension. In 1950, Hummons was invited back to Ashland to attend its opening as a museum. He attended and gave an interview recalling significant memories of his life there. Hummons is pictured here c. 1951 with two children, identified on the photograph as Larry and Cary Bogard.

H. C. McDOWELL. THOMAS CLAY McDOWELL.

1896.

CATALOGUE

OF

TROTTING STOCK

BELONGING TO

H. C. McDOWELL & SON,

OF ASHLAND.

POST-OFFICE, LEXINGTON, KY.

F. E. DRIVER, Superintendent.

HARRODSBURG, KY.
DEMOCRAT PRINTING CO., CATALOGUE PRINTERS.
1896.

One of the primary reasons Henry Clay McDowell wanted to purchase and live at Ashland was to enhance his growing Standardbred enterprise. Henry Clay McDowell, and his son Thomas, bred some of the finest trotters in the country, winning a substantial number of races. The significance of Ashland as the home of the great statesman Henry Clay, and the power of both the Clay and McDowell names, helped to legitimize trotting in Kentucky. This is one of many catalogs printed by the McDowells advertising breeding stock.

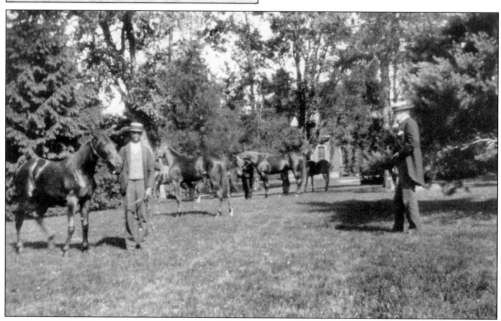

Major McDowell was extremely proud of his horses and made a habit of showing them off to Ashland visitors. The major is seen here, to the right, overseeing a parade of horses led by African American grooms. This particular show was arranged for a visit by an organization of printers called the United Typothetae of America on October 23, 1891.

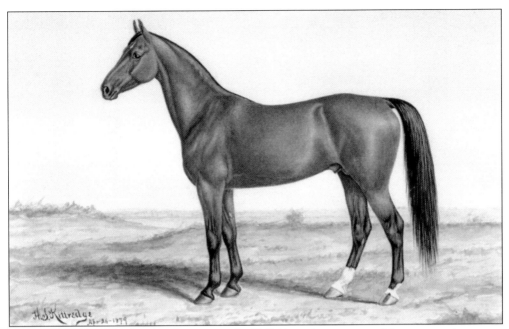

King Rene, the Standardbred in this painting by H. S. Kittredge, was one of the two most important stallions that Major McDowell owned at Ashland. King Rene was known far and wide as the "king of the ring," winning a number of major stock shows in his career. King Rene was highly sought after at stud, and his bloodlines traced back to James Brown Clay's horse, Mambrino Chief, which had earlier stood at Ashland.

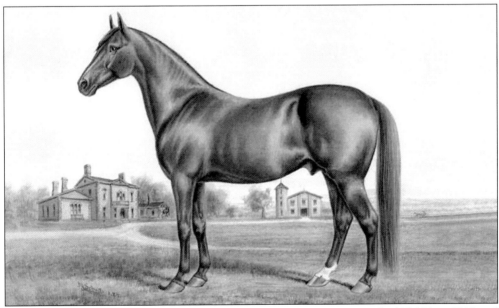

Major McDowell bought his other stallion, Dictator, with two partners for $25,000 in 1883 and brought him to Ashland to stand at stud for $300 per service. Dictator produced so many fine trotters that Major McDowell ultimately bought out his partners. He died at age 30 in 1893 and was buried near the barn behind him in this picture. (Courtesy of the University of Kentucky Library Department of Special Collections and Digital Projects.)

Major McDowell and neighbors living across Richmond Road laid out, surveyed, and purchased the land needed to create a "pleasure drive" extending from the city limits to Lake Ellerslie (near the present city reservoir). This two-mile drive was to be used by horses, carriages, and wagons for touring some of Fayette County's finest farms. In April 1900, the Fiscal Court of Fayette County voted to name the boulevard the McDowell Speedway in honor of the man who had conceived it. A commemorative monument was installed in 1902. Shortly thereafter, the Elks Club held a wagon race on the Speedway, and other races may have followed. By 1909, the Speedway was paved, making it more accessible to the new neighborhoods being built along it, as well as to the growing number of cars traveling it. Today the monument stands in the median of Richmond Road, within sight of the Ashland mansion. (Courtesy of the University of Kentucky Library Department of Special Collections and Digital Projects.)

Thomas Clay McDowell, like his father, developed a strong interest in horses. Initially he entered into partnership with his father in the Ashland Stud trotting operation. Ultimately, however, Thomas made the decision to enter the Thoroughbred business, breeding and racing some of the most successful horses of the early 20th century. (Image from *Coach and Saddle Magazine*, January 28, 1904.)

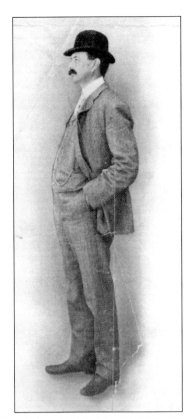

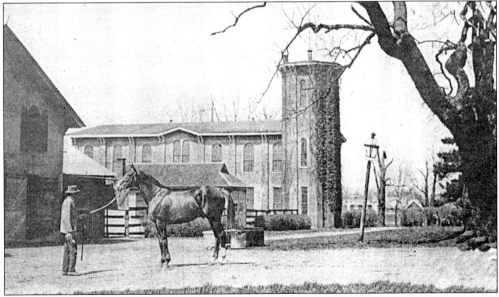

When his father died, Thomas Clay McDowell took over use of the family horse barn, pictured here in the 1920s. During his impressive breeding and racing career, the barn would house at least one Kentucky Derby winner, three Kentucky Oaks winners, and numerous other stakes winners. (Courtesy of the University of Kentucky Library Department of Special Collections and Digital Projects.)

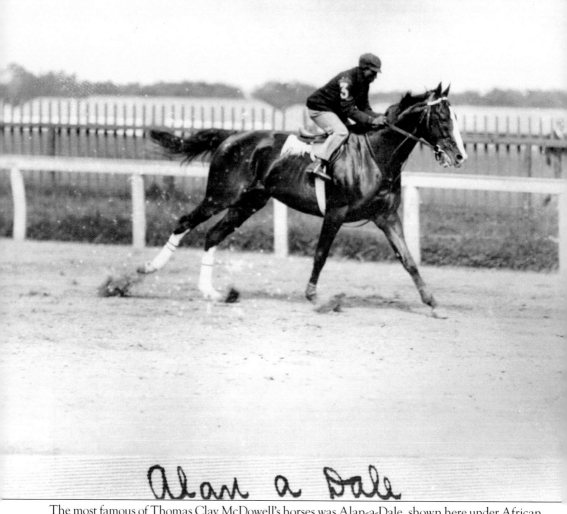

Alan a Dale

The most famous of Thomas Clay McDowell's horses was Alan-a-Dale, shown here under African American jockey Jimmy Winkfield in the 1902 Kentucky Derby. With Alan-a-Dale, McDowell became one of only three men in history to own, breed, and train a Kentucky Derby winner, all within a single year. Alan-a-Dale ran what is considered one of the most exciting of all Kentucky Derbies, outrunning three other horses of which one, the Rival, was also owned and trained by Thomas Clay McDowell. Jockey Jimmy Winkfield manipulated the training of the two horses, ensuring he would ride the faster Alan-a-Dale. Winkfield rode a brilliant race, forcing the other riders to the outside of the track and into the sand piled there. The sand slowed down the other horses and protected a tiring Alan-a-Dale. Winkfield's strategy made Alan-a-Dale the only Kentucky Derby winner in history to race just once as a three-year-old. Alan-a-Dale went on to a successful breeding career at Ashland and, upon his death, was buried next to one of Ashland's horse barns. (Courtesy of Churchill Downs Incorporated/Kinetic Corporation.)

Of all the Clay family members who made their home at Ashland, only the McDowells were extensively photographed while at leisure. There are many photographs similar to this one of Major McDowell relaxing with a book in his study, which tells us a great deal both about life at Ashland and the family's possessions. This information has proven to be extremely useful in the modern interpretation of the house and its occupants.

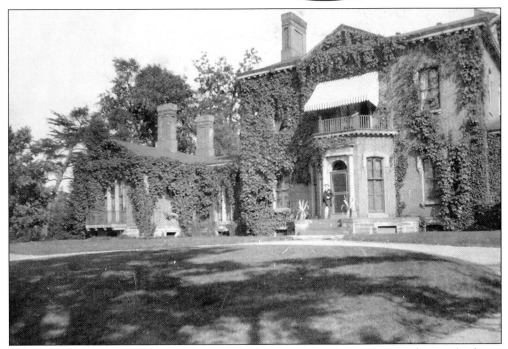

This is another picture of Major McDowell relaxing on Ashland's front steps, admiring his lawn. The McDowells, like all the generations of the family, enjoyed the grounds of Ashland a great deal. (Courtesy of the University of Kentucky Library Department of Special Collections and Digital Programs.)

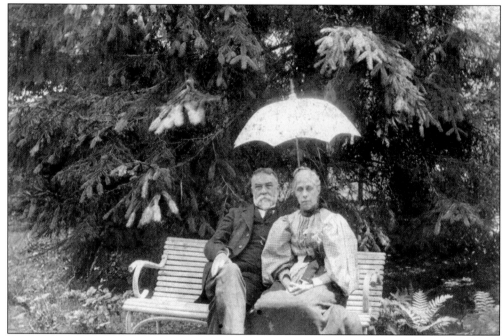

This photograph shows Major McDowell and his wife, Anne Clay McDowell, relaxing on a wooden bench at Ashland. There were many such benches, and it is uncertain where this particular one was located. (Courtesy of the University of Kentucky Library Department of Special Collections and Digital Programs.)

One of the improvements to the grounds implemented by the McDowells was the restoration of the formal garden. It had suffered neglect during the Kentucky University years, requiring the McDowells to literally rebuild it. This photograph shows their garden, which was located between the back lawn of the house and the current garden installed in 1950 by the Garden Club of Lexington. The sundial was moved from the McDowell garden into the current one. (Courtesy of the University of Kentucky Library Department of Special Collections and Digital Projects.)

This picture shows a part of the McDowell driveway. The drive swept down from the front of the house and across to Richmond Road, between what is today McDowell and Sycamore Roads. The McDowells improved the drive and entrance to Ashland during their residency. (Courtesy of the University of Kentucky Library Department of Special Collections and Digital Projects.)

This photograph shows one of the many walking paths on the grounds at Ashland. These walks were a treasured inheritance from earlier generations, and the McDowells used them often. (Courtesy of the University of Kentucky Library Department of Special Collections and Digital Projects.)

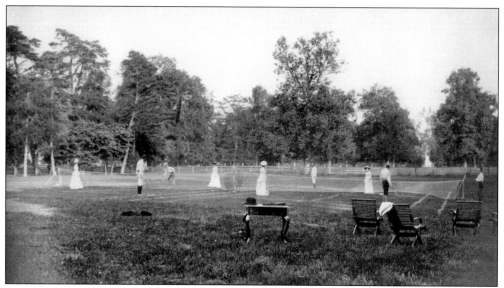

In the 1890s, the McDowells installed two tennis courts on the back lawn and held some of the earliest tennis matches in Lexington there. The matches, between family, friends, and serious players, were sometimes friendly and sometimes competitive. The family occasionally awarded prizes to the winners. This photograph shows tennis matches in action. (Courtesy of the University of Kentucky Library Department of Special Collections and Digital Projects.)

John Fox Jr., the author of *Little Shepherd of Kingdom Come* and many other books, was a family friend and spent much time at Ashland. In this photograph, Fox plays Anne Clay McDowell's *c.* 1840 Martin parlor guitar. This guitar was played by Anne and her children and remains in the collection at Ashland. (Courtesy of the University of Kentucky Library Department of Special Collections and Digital Projects.)

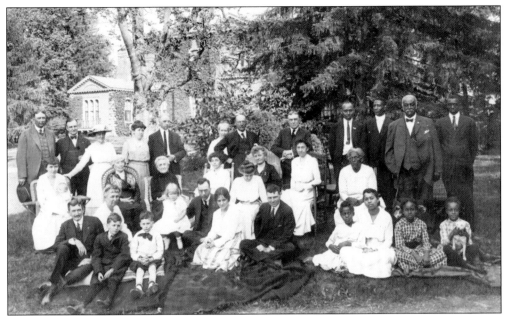

This photograph shows a party thrown at Ashland on May 19, 1917, in celebration of the birthdays of Madeline McDowell Breckinridge and her aunt, Magdalen Harvey McDowell. On the left are family and friends, and on the right are many of the African Americans employed by the McDowells with their children. (Courtesy of the University of Kentucky Library Department of Special Collections and Digital Projects.)

Very few photographs exist of events inside the house and this is the only one taken in the dining room. Anne Clay McDowell sits at the head of the table on the left and Major McDowell sits at the head of the table on the right. Julia McDowell sits next to her mother, facing the photographer in the white puffy-sleeved dress. (Courtesy of the University of Kentucky Library Department of Special Collections and Digital Projects.)

The most important events at Ashland throughout the McDowell era were the weddings of their daughters. Nannette (pictured here) married Thomas Bullock on April 19, 1892. It was an elaborate affair in the drawing room, and dinner was served in the conservatory at the rear of the house. One of the most impressive parts of Nannette's wedding was the electric lights illuminating the house and grounds. (Courtesy of the University of Kentucky Library Department of Special Collections and Digital Projects.)

The next to marry was Madeline McDowell (pictured here) to Desha Breckinridge on November 17, 1898. Unlike her sisters' ceremonies, Madeline's wedding was a very small affair, attended only by close family, perhaps due to Madeline's father's failing health. The ceremony was held at noon and was followed by a wedding breakfast. (Courtesy of the University of Kentucky Library Department of Special Collections and Digital Projects.)

This photograph is of Madeline's husband, Desha Breckinridge, a member of another established and important Kentucky family. His father had connections to the Clays going back to his first wife, who was a granddaughter of Henry Clay. Breckinridge was a longtime editor of Lexington's morning paper, the *Herald*. (Courtesy of the University of Kentucky Library Department of Special Collections and Digital Projects.)

Julia P. McD

Julia McDowell was the last to get married on November 12, 1904, five years after her father died, to William Bass Brock. According to newspaper accounts, Julia, seen in this photograph about the time of her wedding, was married in the dining room, had a reception in the drawing room, and had dinner in the "two library rooms." (Courtesy of the University of Kentucky Library Department of Special Collections and Digital Projects.)

Nannette McDowell Bullock and her husband, Thomas Stapleton Bullock, are shown in this photograph taken some time after they were married. Initially the Bullocks set up housekeeping in Louisville, Kentucky, where Dr. Bullock had a medical practice. In 1900, he was forced to close his practice due to illness, and the family relocated to New Mexico to aid his recovery. In 1903, the Bullocks moved into Ashland to care for Nannette's mother and remained there for the rest of their lives. Nannette ultimately became mistress of Ashland after her mother's death in 1917. It was Nannette, a great-granddaughter of Henry Clay, who would advocate the preservation of Ashland as a museum, a measure ultimately achieved under her will. This picture may have been taken at Ashland, as it shows family furniture and objects that are now part of Ashland's collection. (Courtesy of the University of Kentucky Library Department of Special Collections and Digital Projects.)

On November 27, 1893, Thomas and Nannette Bullock welcomed their only child, Henry McDowell Bullock. One of the greatest benefits of Henry's heritage was spending his childhood enjoying the family farm, which ultimately became his home. Here Henry is seated on his pony (at the far right) playing with friends on the grounds of Ashland. (Courtesy of the University of Kentucky Library Department of Special Collections and Digital Projects.)

Henry McDowell Bullock grew up to be a handsome young man. He never married or engaged in any particular occupation but ultimately took as his vocation the care of his mother and Ashland, his ancestral home. Henry Bullock would be the last family member to reside at Ashland, doing so until 1959. (Courtesy of the University of Kentucky Library Department of Special Collections and Digital Projects.)

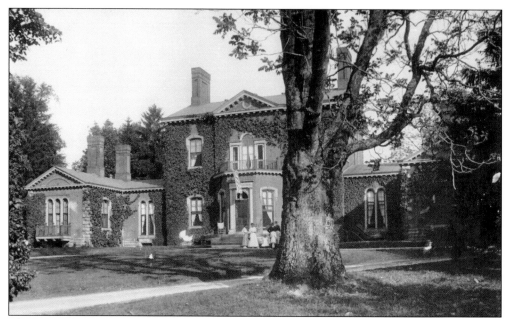

This image shows Ashland as it looked during the Bullock era, and standing in front are McDowell family members. The pram under the window was likely for one of Anne Clay McDowell's grandchildren. (Courtesy of the University of Kentucky Library Department of Special Collections and Digital Projects.)

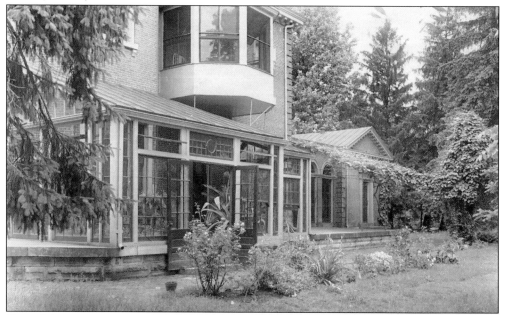

One of the improvements made to Ashland by the Bullocks was the addition of this sleeping porch. It was built over the conservatory and accessed through a window in the upstairs master bedroom. Its purpose was to create a cool place to sleep on hot summer nights; however, there were questions about its stability. Madeline McDowell Breckinridge refused to sleep there because she feared for her safety. (Courtesy of the University of Kentucky Library Department of Special Collections and Digital Projects.)

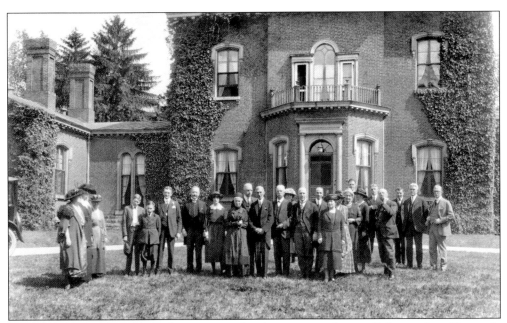

On May 8, 1921, Ashland hosted a major social and international event. Delegates from Venezuela traveled to Lexington to pay their respects to Henry Clay, whose support of emerging South American republics helped birth their nation. The delegation placed a bronze wreath on the back wall of the chamber in the Henry Clay Monument at Lexington Cemetery and also visited Ashland. This photograph shows the delegation and several Clay family members in front of the house. (Courtesy of the University of Kentucky Library Department of Special Collections and Digital Projects.)

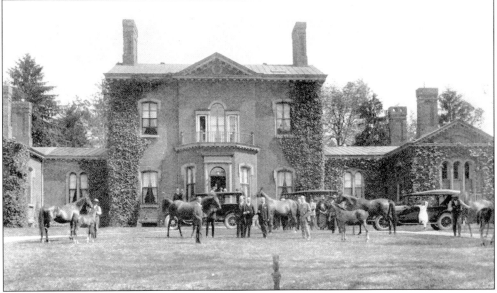

Thomas Clay McDowell, like his father, chose to entertain guests with a parade of horses. This photograph shows horses being admired by members of the Venezuelan delegation. The cars parked along the drive apparently brought the delegation and other family to Ashland. (Photograph from *Madeline McDowell Breckinridge* by Sophonisba Breckinridge.)

VOTE YES [X]
FOR PARK BONDS

$100,000 For Ashland—$100,000 For Other Parks

SAVE ASHLAND
HONOR HENRY CLAY
BOOST LEXINGTON

ELECTION TUESDAY, NOVEMBER 2, 1926

HENRY CLAY MEMORIAL FOUNDATION

By the early 1920s, Nannette McDowell Bullock and her siblings realized that they could not reasonably prevent continued development of the Ashland estate. With the aging house, it became more costly and complicated to maintain Ashland. The family feared that Ashland might be lost and, with it, the legacy of one of Kentucky's greatest figures. To ensure its preservation, Nannette spearheaded the creation of the Henry Clay Memorial Foundation. The foundation was established to coordinate an effort to issue fund-raising bonds to operate the house as a museum and the historic grounds as a park. A city-wide bond measure appeared on the ballot in November 1926. Cards such as this were printed and distributed to encourage people to vote for the bond issue to enable the foundation to begin operations. Unfortunately, despite significant effort by local historian and judge Samuel Wilson, the measure failed. The Henry Clay Memorial Foundation would have to wait another 22 years to acquire Ashland.

By 1907, Lexington had grown to the point that the city limits reached the Ashland property. By 1920, the western end of the farm had been sold for residential development, forming the Ashland Park neighborhood. Additionally many of the farms across Richmond Road were subdivided and developed. This photograph shows the entrance to Ashland on the improved Richmond Road. (Courtesy of the University of Kentucky Library Department of Special Collections and Digital Projects.)

By 1926, additional sections of the farm were divided into residential lots, changing the location of the original entrance. A driveway was installed from the newly created Sycamore Road in front of the mansion, as seen on this map. The McDowell horse barn was also torn down to make way for Sycamore Road. This map shows the model home built by a local newspaper under editor Desha Breckinridge.

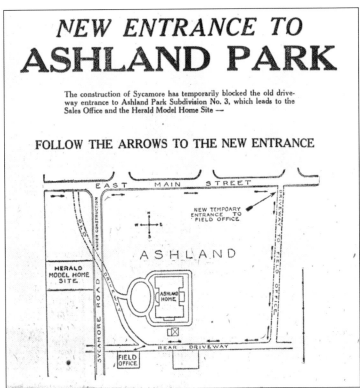

NEW ENTRANCE TO

ASHLAND PARK

The construction of Sycamore has temporarily blocked the old driveway entrance to Ashland Park Subdivision No. 3, which leads to the Sales Office and the Herald Model Home Site —

FOLLOW THE ARROWS TO THE NEW ENTRANCE

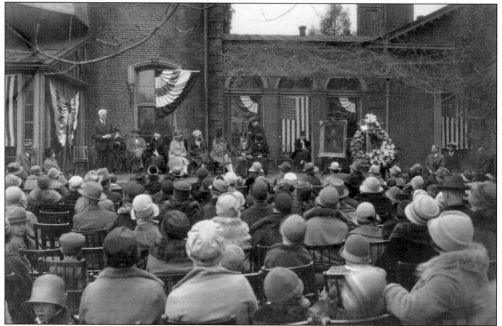

This photograph was taken in 1927 at the celebration of the 150th anniversary of Clay's birth. During the ceremony, a painting of Henry Clay was donated to the State of Kentucky. Judge Wilson, a longtime proponent of Ashland as a museum, officiated at this event. (Courtesy of the University of Kentucky Library Department of Special Collections and Digital Projects.)

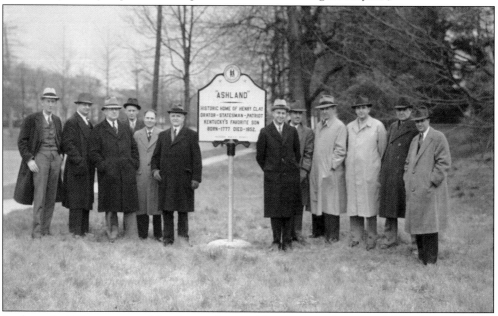

In the early 1930s, a group of family members and historians gathered at Ashland to unveil the first Kentucky Highway Historical Marker. This marker originally stood on Richmond Road but has since been moved to the parking lot area on the estate. Since its dedication, literally hundreds have been installed at historic sites around the state. (Courtesy of the University of Kentucky Library Department of Special Collections and Digital Projects.)

Five

OPEN TO THE PUBLIC
The Museum Era

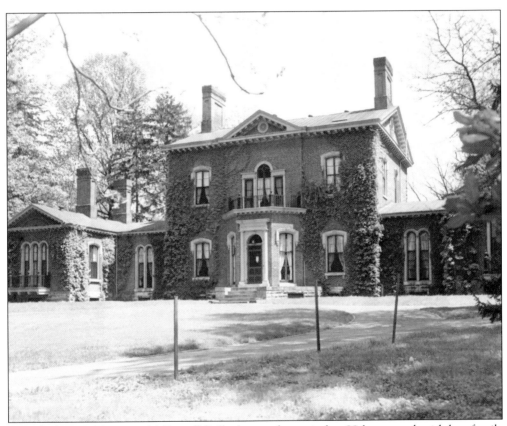

On July 5, 1948, Nannette McDowell Bullock passed away in her 88th year and, with her, family ownership of Ashland. Nannette's will stipulated that the remaining 17 acres of the estate would become the property of the Henry Clay Memorial Foundation and her son, Henry McDowell Bullock, would have a life estate permitting him residence in the mansion. Her will also provided for an endowment enabling the foundation to purchase and later operate the house as a museum. It stated that the museum was to serve as a memorial to her great-grandfather Henry Clay and her sister Madeline McDowell Breckinridge. The grounds of the estate were to be made available to the public for pleasure and recreation. Nearly four decades after her initial vision, Nannette made it a reality by means of her will. This image shows the house as it looked about the time it opened as a museum in 1950.

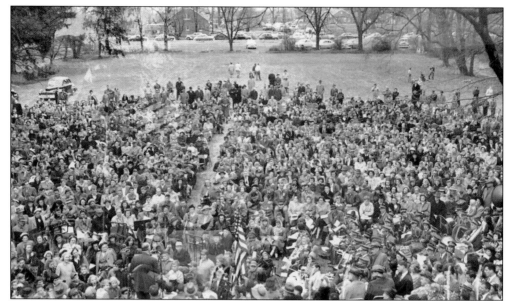

On April 12, 1950 (the 173rd birthday of Henry Clay), the Henry Clay Memorial Foundation opened Ashland, the Henry Clay Estate, as a historic house museum. It was a major event with Vice President Alben Barkley, a Kentuckian, as the keynote speaker. The festivities began with a luncheon to honor Vice President and Mrs. Barkley, followed by musical performances and introductions, culminating in his speech. This photograph shows the crowd gathered at Ashland for the event.

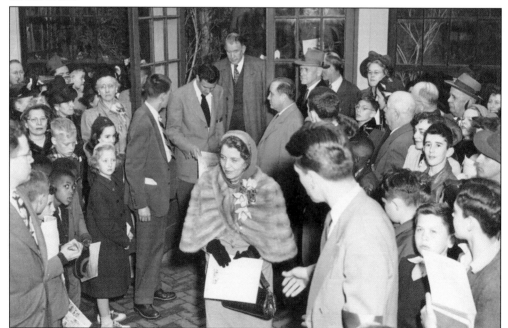

One of the guests at Ashland's opening event managed to upstage the vice president, and that guest was none other than his wife. Jane Hadley Barkley (seen here center, wearing a fur wrap just ahead of her husband in the doorway) was a young socialite who attracted a lot of attention. In this photograph, the Barkleys are exiting the conservatory located at the rear of the house.

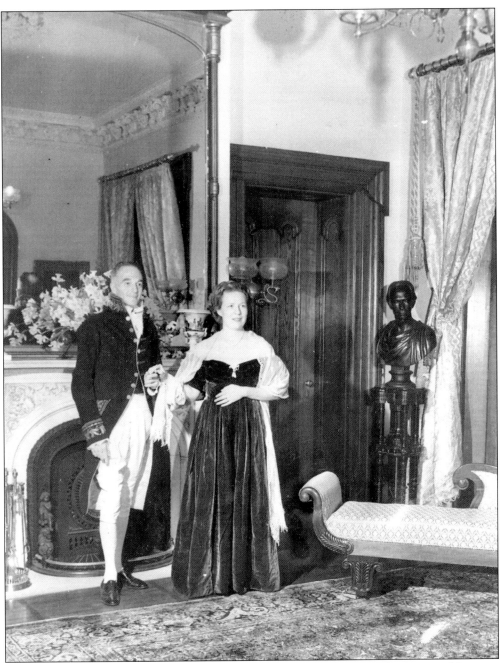

One of the many attractions at the grand opening was the attendance of "Henry and Lucretia Clay." They were portrayed by descendants William Clay Goodloe McDowell and his niece, Mary Stucky Platt. For authenticity, Mr. McDowell wore the coat used by Henry Clay at the signing of the Treaty of Ghent, and Mrs. Platt wore a red velvet dress said to have belonged to a Clay ancestor. Mrs. Platt and Mr. McDowell are shown here posed in the drawing room in the historic finery. Both garments are still in Ashland's collection, and the coat has since been conserved.

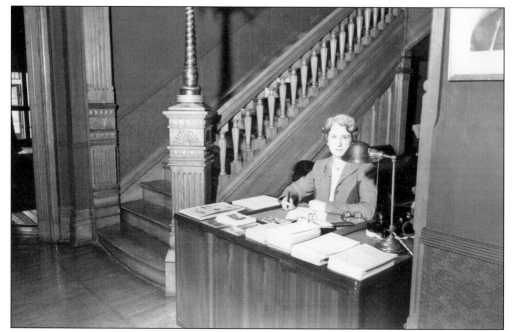

When the Henry Clay Memorial Foundation opened Ashland to the public in 1950, Lorraine Seay was hired to administer it. Mrs. Seay was executive director but also served as curator, maintenance technician, and tour guide. She would become the heart and soul of Ashland for nearly four decades. This photograph shows her sitting at the desk she installed in the mansion's front entryway.

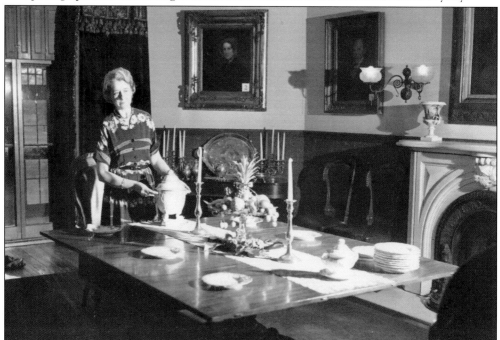

In this photograph, Mrs. Seay is seen arranging Lucretia Clay's dessert service on the dining room table. Although she had no formal training in curatorial methods, Mrs. Seay cared for and arranged all the artifacts at Ashland with devotion and dedication.

In addition to her other duties, Mrs. Seay was Ashland's primary tour guide, but visitors were also allowed to take self-directed tours. Though some barriers were erected, rooms were largely accessible. Here Mrs. Seay (at right) is seen interpreting the drawing room. Current museum practice provides much greater protection for artifacts in the collection.

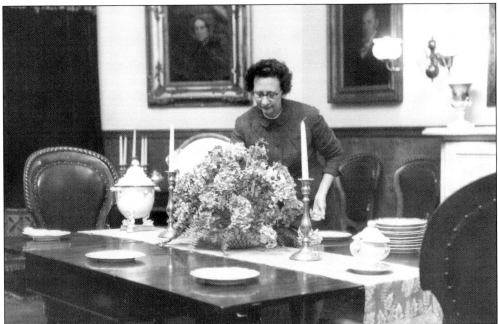

When Ashland initially opened, a Mrs. Craig, seen here arranging a bouquet of fresh flowers on the dining room table, was placed in charge of floral design in the house. For many years, fresh and dried flowers were used throughout the mansion. This practice has since been discontinued in favor of artificial arrangements, which are less harmful to the collection.

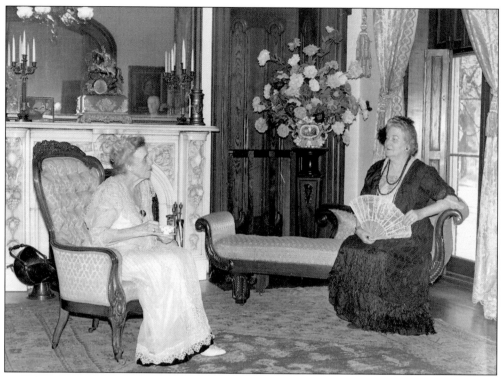

This image is of two members of the Lexington Woman's Club dressed in vintage clothing and having tea in the drawing room. Early in Ashland's existence as a museum, events were held in the house using artifacts from the collection. This is a reflection of the different standards of museum stewardship. The sofa pictured here once belonged to Henry Clay. The chair is part of James B. Clay's Ash set.

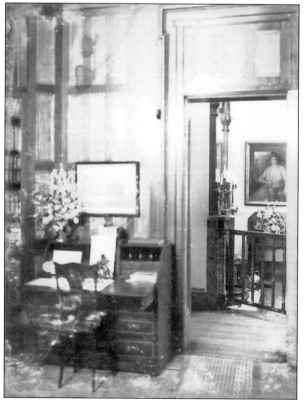

Since the home's opening as a museum in 1950, access to certain areas and rooms of the house has varied. At the far right of this picture, the wooden barricade across the corner of the billiard room is visible. Visitors were allowed to see into the room but not to enter it. Today visitors have full access to this room.

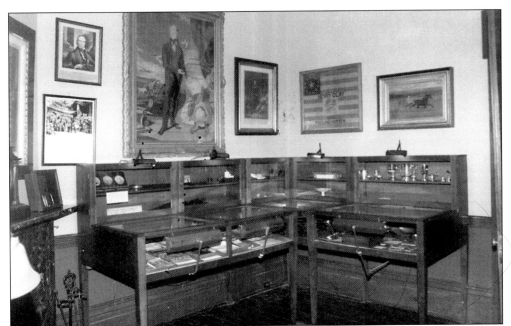

One of the unique features of the early museum was "the museum room," which contained display cases for small artifacts, documents, and other delicate or difficult-to-view items. This room is now interpreted as Henry Clay's study while another room has been set aside as a permanent exhibit area that contains difficult-to-view items as well as information on the life and career of Henry Clay.

Shortly after its opening in 1950, the Henry Clay Memorial Foundation produced this advertisement for Ashland. It is one of the earliest invitations to visit and join a membership organization in support of Ashland, now called the Friends of Ashland. The invitation shows an admission cost of only 50¢ for adults and 25¢ for children. (Courtesy of the University of Kentucky Library Department of Special Collections and Digital Projects.)

AN INVITATION
from
HENRY CLAY'S HOME

Perhaps you will want to join the thousands who visit the historic old home of Henry Clay, located just two miles east of downtown Lexington, Ky. on U. S. 25. Visitors to the Blue Grass and groups of students acclaim it one of the most interesting shrines in Kentucky. If you would like to share in the task of preserving this old historic landmark, you are invited to become a member of the
HENRY CLAY
MEMORIAL FOUNDATION
OPEN DAILY (Except Monday)
9:30 a.m. to 4:30 p.m.
Children 25c Adults 50c

Ashland, home of Henry Clay, noted colonial
statesman, in Lexington.
Photo courtesy Tebbs and Knell, N. Y.

This image is taken from one of the first tourist publications printed about Ashland after its opening in 1950. It shows the front entrance essentially unchanged since leaving family ownership. The caption refers to Henry Clay as a Colonial statesman, but he was born in 1777, near the end of the Colonial period. This is an example of the ongoing challenge Ashland has faced to prevent the spread of inaccurate information.

This photograph shows furnishings in Ashland's drawing room. At the upper right corner of the small portrait, to the right of Henry Clay's bust, is a black square showing the number "9," which corresponded to an entry on a list of artwork and artifacts. It was used by tour guides for information on items in the collection. Artifact lists are still in use at Ashland today, but numbers are no longer affixed to the artifacts.

This image depicts two young visitors viewing an 1844 Henry Clay presidential campaign banner on display in the drawing room. They were allowed much greater access to this room than is permitted today.

One of Ashland's bedchambers is shown in this photograph. In the museum's early years, the display case on the left was used for clothing and related artifacts. Today clothing is exhibited on mannequins for limited periods. Three garments are visible in the case: the jacket worn by Henry Clay at the signing of the Treaty of Ghent, the red dress worn at the opening of Ashland, and a green dressing gown.

Mrs. W. T. Lafferty, seen in this 1959 photograph, was the first chairwoman of the Arts Committee of the Henry Clay Memorial Foundation and sought out donations to the museum. From the time Ashland opened, the foundation strongly encouraged interested parties to donate artifacts for display in the house. The response was positive, and a steady stream of items came through Ashland's doors. (Courtesy of the University of Kentucky Library Department of Special Collections and Digital Projects.)

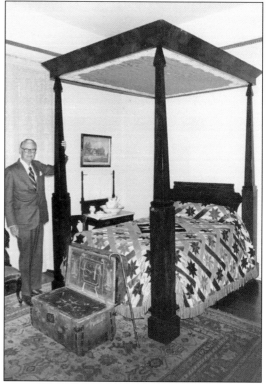

Henry Clay Simpson, a great-great-grandson of Henry Clay, is standing with his hand on Henry Clay's bed. It was made in Lexington and enjoyed by Clay, who wrote a testimonial for its maker in the local paper. According to family members, Simpson donated the bed to Ashland because no one had a room that would accommodate it. Many artifacts have come back to Ashland from Clay descendants.

This photograph shows the dining room table with a lace runner that had been given to Lucretia Clay by a group of Irish ladies. Also pictured is her lovely French dessert service. These artifacts were donated by different descendants of separate branches of the Clay family. Only 4 of Henry Clay's 11 children have lines of descent, all of which have generously loaned or donated artifacts to Ashland.

This copy of John Neagle's *Henry Clay as the Father of the American System* was given to Ashland by the State of North Carolina. The state replaced the painting with one of a North Carolina politician and awarded the Clay painting to a local school district named in honor of Henry Clay. When the district failed to retrieve the painting, it was given to Ashland. It is now considered one of the most important artifacts in the collection.

During the early days of the museum, it was not uncommon to arrange small presentation ceremonies in appreciation of individuals donating objects to the foundation. This photograph is of one such ceremony. The gentleman in the wheelchair is presenting a framed object held by Executive Director Lorraine Seay (left).

In addition to the mansion, the foundation also utilized Ashland's historic outbuildings. This image shows the smokehouse (with wings added during the McDowell era), which opened as an exhibit with Henry Clay's carriage installed in the left wing. The other wing was apparently used as an exhibit area. Later public bathrooms were added to the carriage wing but were ultimately removed.

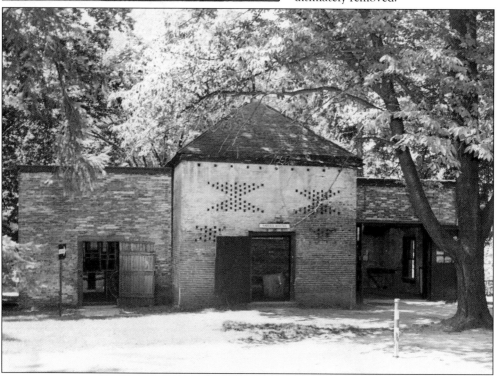

When the Henry Clay Memorial Foundation opened Ashland in 1950, a formal garden was installed on the property. The project was funded and overseen by the Garden Club of Lexington. Landscape architect Henry Fletcher Kenney designed the new formal garden. Because of the lack of information about Henry and Lucretia Clay's original garden, Kenney designed an 18th-century formal, six-parterre-style garden. Club members donated many of the plants used in creating the garden, and one of them, Mrs. Henry B. Tilden, is seen here.

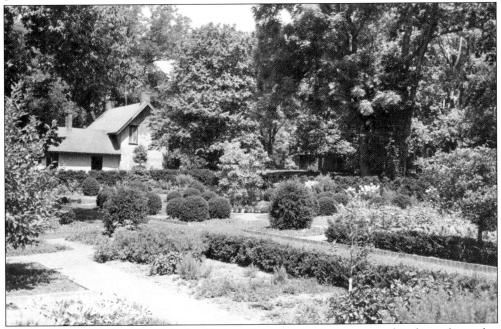

The garden grew to be one of the highlights of the Ashland property and is shown here after several seasons of growth and maturity. The Garden Club of Lexington is in its 56th year of providing all the upkeep and maintenance. Many club members come to work in the garden each Wednesday morning throughout the growing season.

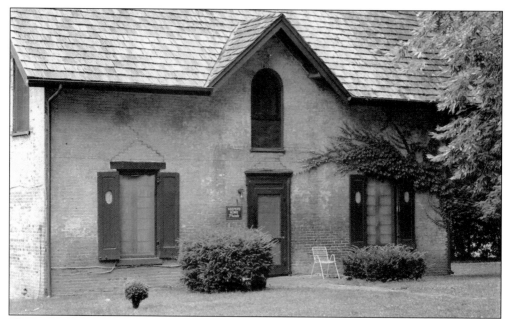

The cottage was put into service as a residence for a property overseer. Along with maintenance and upkeep duties, the overseer provided security to the site outside of business hours. Howard Hill, who held this job and lived in the cottage with his wife for about 30 years, is still remembered by many neighborhood residents.

In 1957, the University of Kentucky undertook the task of printing a comprehensive collection of Henry Clay's papers. A nationwide search found many letters, personal documents, and speeches written by, or to, him. Pictured is the celebration of the first of 11 published volumes of *The Papers of Henry Clay*. Pictured from left to right are James F. Hopkins, original editor; Dr. Mary Wilma Hargreaves, assistant editor; Lorraine Seay; and Dr. Thomas Clark, University of Kentucky history professor. (Courtesy of the University of Kentucky Library Department of Special Collections and Digital Projects.)

In 1960, Ashland received another in a long line of distinguished visitors when Pat Nixon, wife of Vice President Richard Nixon, visited Ashland. Mrs. Nixon visited Lexington during her husband's presidential campaign and was greeted at Ashland by several thousand people. She was escorted by Mrs. John Sherman Cooper, whose husband was a Kentucky senator. Mrs. Nixon (left) admired the bust of Henry Clay as Mrs. Cooper looked on.

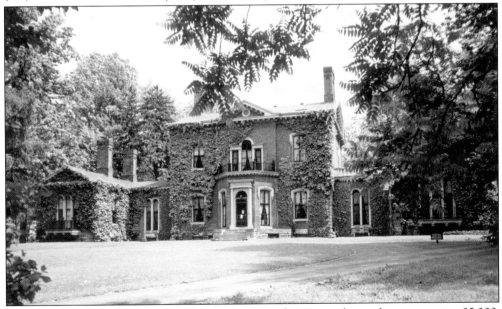

By 1960, Ashland was a bustling tourist attraction with an annual attendance averaging 25,000. In just one decade, the Henry Clay Memorial Foundation had made Ashland one of Kentucky's foremost public historic sites. This photograph shows Ashland at about that time.

This photograph shows members of the Foundation Board about 1960. Mrs. Seay (fourth from the left) stands next to H. L. Donovan (fourth from the right). Not pictured is Joe Graves, president of the board. Mr. Graves served many years on the board and has been followed by his son, Joe Graves Jr., now a board member emeritus. (Courtesy of the University of Kentucky Library Department of Special Collections and Digital Projects.)

On December 19, 1960, Ashland achieved another milestone by being named one of the first two National Historic Landmarks designated in Kentucky. In this photograph, Perry Brown of the National Park Service (left) presents the certificate showing Ashland's new status to Lorraine Seay (center). Kentucky state historian and Ashland supporter Dr. Thomas Clark looks on.

Ashland received a bronze plaque to commemorate its designation as a National Historic Landmark. In this photograph, Perry Brown of the National Park Service (right) hands the plaque to Dr. Thomas Clark. It was mounted and remains beside the front door to the mansion.

Over the years, Ashland has served as a backdrop for student photographs like this one taken about 1955 of University of Kentucky student Judy Omohundro. Although no photography is allowed inside the mansion today, students continue to visit Ashland every year to have their pictures taken on the grounds.

This image is of the University of Kentucky Quartette c. 1955. It was likely taken during an event at Ashland featuring a performance by the musical group.

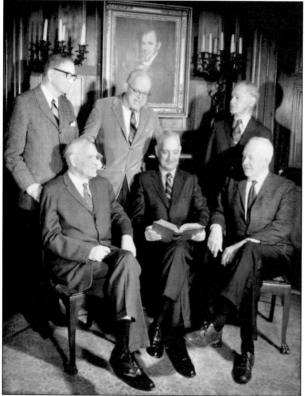

On April 3, 1971, one of the most memorable gatherings in the history of Ashland as a museum occurred in the library. Six of Kentucky's most famous and important historians assembled at the historic site for a visit. Pictured here from left to right are (first row) Clement Eaton, Thomas Clark, and J. Winston Coleman; (second row) Albert Kirwan, Holman Hamilton, and Hambleton Tapp. (Photograph by John Malick.)

Although Ashland's last resident, Henry McDowell Bullock, moved out in 1959, Ashland was occupied until 1976 by a feline resident. Gypsy the cat wandered into the house through an open window in 1962. Although Lorraine Seay tried to evict Gypsy, the cat always returned to the house. Finally Mrs. Seay allowed Gypsy to stay, and for the next 14 years, Gypsy was a favorite with visitors. She died on December 6, 1976, and was buried beneath a tree on the front lawn. Donations were collected to erect a small headstone in her memory.

This photograph, taken in the 1970s, shows the chamber interpreted at the time as Henry Clay's bedroom. The bed and trunk both belonged to Henry Clay, and the quilt was a gift to him from the Whig Ladies of Philadelphia.

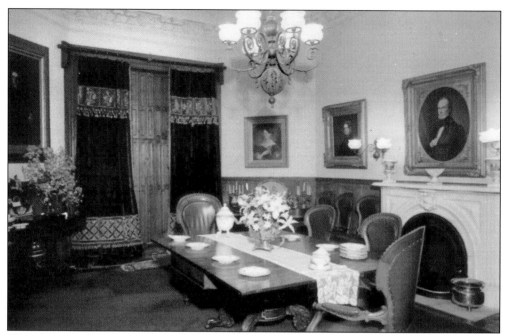

This photograph shows Ashland's dining room in the late 1970s, which remains very much the same today. On the table are Lucretia Clay's lace runner and dessert service. Looking down on the table is a portrait of Henry Clay by a Portuguese artist who resided in France. Henry Clay is posed in the Napoleonic fashion.

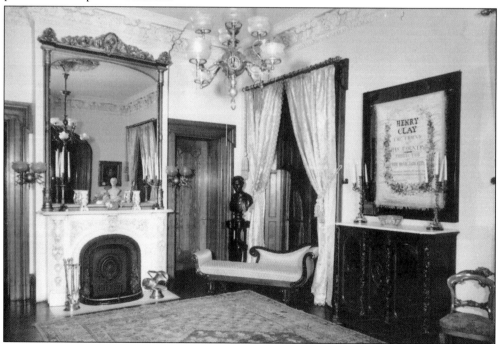

This image is of the drawing room in the 1970s. The banner is from Henry Clay's 1844 campaign and hangs over the Belter cabinet designed by son James. The sofa belonged to Henry Clay, and the bust of Clay is by an unknown artist.

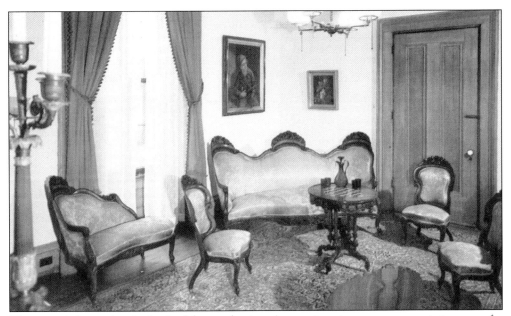

This room is located at the back of the north wing. At one time, it was set up as a sitting room for Henry Clay's great-granddaughter, Nannette McDowell Bullock, and interpreted in her honor. In the early years of the museum, there was a lack of family furniture. The Belter-style suite pictured here belonged to a McDowell in-law and was donated to Ashland because it was of an appropriate period. The room is now interpreted according to its historical usage as a billiard room.

This is a view of another room containing some of the artifacts from Henry Clay's bedroom. Rooms were rearranged as new pieces were donated, additional research conducted, and new themes developed.

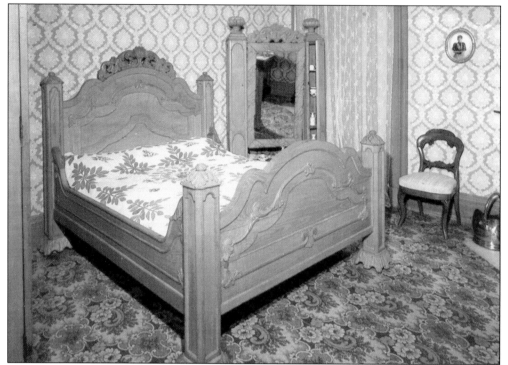

Pictured here in an upstairs bedroom is James Brown Clay's ash furniture. The suite was originally divided up and used throughout the house before being consolidated into one room as it is today. The quilt on the bed was a gift to Henry Clay and is a fine example of American homespun textiles.

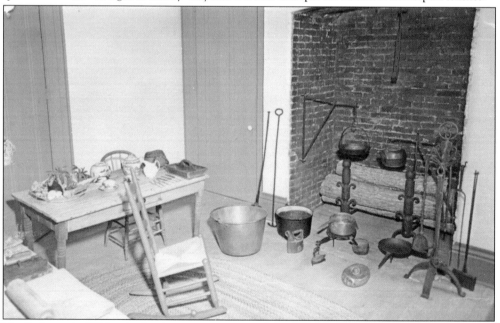

Until the early 1990s, the kitchen was interpreted in the south wing on the back side of the house. In this photograph, it is arranged to represent a kitchen as it would have been in Henry Clay's lifetime.

By the late 1980s, Ashland's mansion had fallen into serious disrepair and was in need of extensive restoration. In this photograph, Betty Kerr, executive director throughout the 1980s, is seen viewing deteriorated stone in the terrace.

Masonry deterioration, including cracking and displacement of bricks over a window, is evident in this photograph. Such damage was not surprising, considering Ashland had not been renovated in approximately 80 years. At the time this picture was taken, the structure had been essentially untouched since its construction by Henry Clay's son James in 1856.

More evidence of deterioration is shown here in the form of a damaged block at the bottom of the railing on a side porch now used as the main visitor entrance. Such deterioration was not only unsightly but, without restoration, would ultimately have become a safety issue.

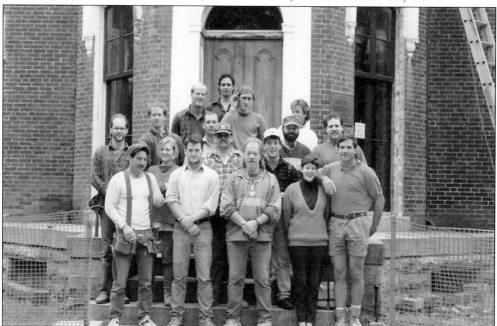

In 1991, an extensive restoration of Ashland was begun. The City of Lexington issued bonds to help pay for the project, and an architect from Cincinnati was hired to manage it. Pictured here are employees of Phase IV, the general contracting firm selected to carry out the project. One of the owners and a current Ashland board member, Bill Campbell, is pictured at the bottom right. (Courtesy of Phase IV.)

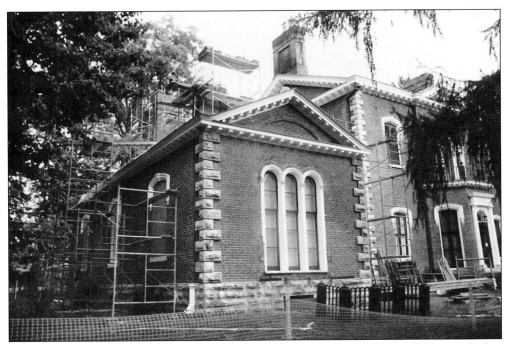

Ashland is pictured here with restoration well underway, as indicated by the scaffolding and other equipment used for the project. The restoration included major exterior and interior work, and the intent was twofold: to improve Ashland's appearance and to stabilize it for future generations. (Courtesy of Phase IV.)

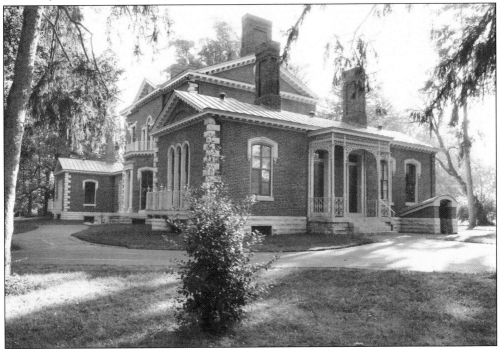

The restoration was completed and the house reopened to great fanfare in September 1992. This photograph shows the exterior of the fully restored Ashland.

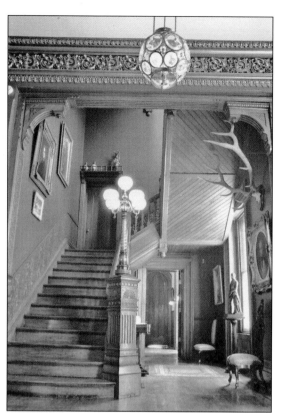

Interior paint colors and wall finishes were chosen based on extensive paint analysis and what would have been popular during the McDowell era (1883–1917). Some of the original McDowell wall treatments were restored, and all of the light fixtures were also conserved. This photograph is of the entrance hall after restoration.

After the restoration, rooms were interpreted using photographs taken by the McDowell family in the early 20th century. These photographs were used because they provided the only historic reference available for placing furniture in the house. This is the drawing room, photographed in early 2006 and arranged according to the McDowell photographs.

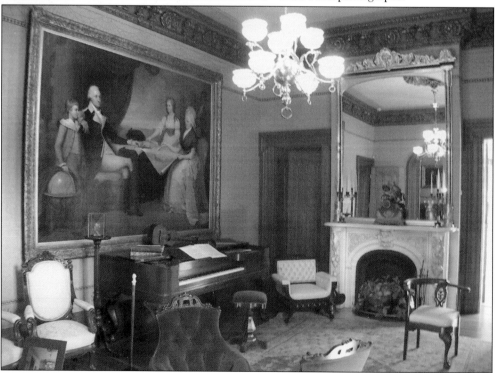

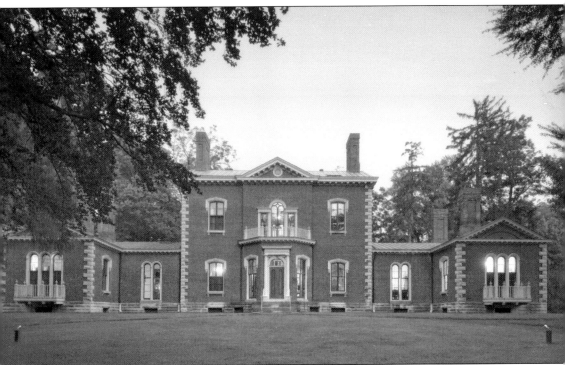

Today Ashland enters its third century since first becoming Henry Clay's farm in 1804, and it continues to be as vibrant as ever. The staff has grown to include a full-time executive director and curator and 10 part-time employees, and its volunteer docent program has flourished, playing a vital role in the operation of the estate. An average of 15,000 people, including thousands of Kentucky schoolchildren, visit the site each year. Extensive educational and entertaining programs are offered throughout the year, and research is ongoing into the vast legacy of Henry Clay. The Henry Clay Memorial Foundation continues its important mission to preserve Ashland, the Henry Clay Estate, as a National Historic Landmark and educational center for the cultural and social history of the 19th century and specifically to interpret the life and times of Henry Clay, the Clay family, and other residents of Ashland for the public. All of these efforts ensure that Ashland, and the legacy of Henry Clay, will move into a fourth century and beyond. (Photograph by Frank Becker.)

Discover Thousands of Local History Books Featuring Millions of Vintage Images

Arcadia Publishing, the leading local history publisher in the United States, is committed to making history accessible and meaningful through publishing books that celebrate and preserve the heritage of America's people and places.

Find more books like this at
www.arcadiapublishing.com

Search for your hometown history, your old stomping grounds, and even your favorite sports team.

Consistent with our mission to preserve history on a local level, this book was printed in South Carolina on American-made paper and manufactured entirely in the United States. Products carrying the accredited Forest Stewardship Council (FSC) label are printed on 100 percent FSC-certified paper.

MADE IN THE USA